Creative Computer Tools *for Artists*

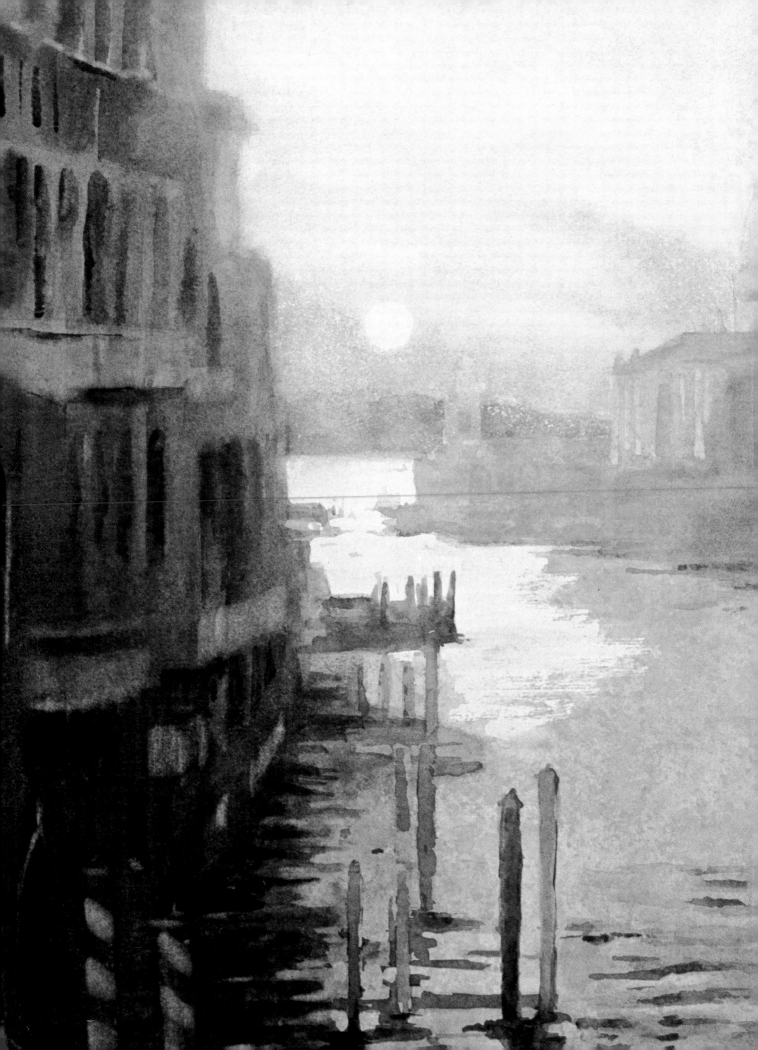

Creative Computer Tools *for* Artists

JANN LAWRENCE POLLARD
AND JERRY JAMES LITTLE

Using Software to Develop Drawings and Paintings

Watson-Guptill Publications
New York

Acknowledgments

First, we want to thank the many professional artists who individually met with us and who developed the excellent art you will find displayed in this book. They enthusiastically participated in the learning process that enabled them to deliver an original art image that was designed and developed by the techniques described in the book. In total, there are approximately 300 color images, which illustrate the step-by-step design composition process leading to the finished artwork.

We also would like to thank the people at Watson-Guptill for their professional help and guidance, especially Joy Aquilino, who has been so knowledgeable and supportive to our cause, Margaret Sobel and Jackie Ching as expert editors, and Jay Anning of Thumb Print for his impressive design and layout skills.

From Jann: Thank you especially to my husband, Gene, for his patience and support during the last year. And thank you to my parents, who are farmers and knew little of art, but always encouraged me to follow whatever path I wanted to choose. It has been a delight working with Jerry Little on this project. We each learned so much from each other.

From Jerry: I would like to thank my wife, Jean, for her support and her encouragement this past year, while we were putting this book together, and of course my co-author Jann Pollard, with whom I worked so many hours.

Pages 2–3: Venetian Sunset *by Jann Lawrence Pollard (see pages 128–130).*

Pages 15–16: Step from Cotswold Burgundy Door *by Jann Lawrence Pollard (see pages 18–20).*

Pages 36–37: Step from Cow in Time Zone *by Edwin Wordell (see pages 63–66).*

Pages 72–73: Steps from Tempest *by Jane Hofstetter (see pages 92–94).*

Pages 100–101: Step from Mont Ste. Victoire, Provence *by Richard McDaniel (see pages 119–121).*

Pages 122–123: Step from West Marin *by Donna McGinnis (see pages 126–127).*

Copyright © 2001 by Jerry James Little and Jann Lawrence Pollard

First published in 2001 by Watson-Guptill Publications, a division of VNU Business Media, Inc., 770 Broadway, New York, N.Y. 10003 www.watsonguptill.com

Library of Congress Catalog Card Number: 2001-093583

ISBN 0-8230-1039-2

Printed in Malaysia

First printing, 2001

1 2 3 4 5 6 7 8 9 / 07 06 05 04 03 02 01

Senior Editor: Joy Aquilino
Editors: Jacqueline Ching and Margaret Sobel
Production Manager: Hector Campbell
Designer: Jay Anning, Thumb Print

Contents

Chapter Four

Scanning Sketches

Chapter Five

Using Digital Effects

Introduction

One thing that all artists know is that there are as many ways to create art as there are tools to aid in the creative process. Most do not count the computer among these tools. However, when used to develop studies for traditional artwork, the computer yields surprising and inspiring results, as the contributors to this book discovered.

We designed this book to introduce the computer as a means to create new ideas and concepts. To broaden the scope of this book, we brought in artists who work in all media from watercolor to oils. You will see how artists from around the world work on the computer to create designs and compositions. Whether you are a beginning or professional artist, you can use a computer to immediately conceptualize and evaluate design, color, and values.

We invited well-known, professional artists to our studios to work with us on the computer. A few of them had attempted it before, while others were new to the concept. In the end, all were amazed at the endless creative possibilities the computer can offer an artist. We asked them to bring photos, sketches, or originals from which to work. Once we scanned their images into the computer, the artists instructed us how to transform them into new compositions, from which they would complete a new painting. This book contains their artwork based on their computer studies, as well as discussions of their personal painting techniques and how the digital process affected them.

Each artist has his or her own technique for developing a painting. This book demonstrates how the computer achieves and complements those techniques. As you follow along and begin to play with your image-editing software, you will see what effects were involved in the development of the conceptual studies. Before long, you will become quite eager to get to your paints.

In addition to a computer, you will need a scanner, a printer, and image-editing software. We used Adobe Photoshop, but any similar program will work. You can easily get started with an inexpensive program, such as Adobe Photoshop Elements. Often a simple program will come with your scanner. In this book, any time the name of a specific Photoshop tool or command is used, it has been capitalized. In different programs, these tools or commands may be called by a different name. Refer to your program's technical manual.

The computer offers artists versatility. With the tools provided by your program, you can experiment with a photograph by testing various colors, values, and compositions before touching paper or canvas. You have the choice of using your computer sketch as your final composition or using it as a reference, as you would a photograph. For commercial artists, you have the option of displaying your ideas to a client, so both of you will feel more confident and in agreement.

New technology has always been brought into the fine artist's repertoire of tools, often with initial resistance. When the camera was first introduced, many artists did not consider using it or hid the fact that they used it in the creative process. Yet today, the camera is useful to artists in capturing their initial impressions or visions.

Nevertheless, there is still a bias against the use of a computer in the creation of art. Some might think that what results cannot be considered "true art." Nothing could be further from the truth. Others argue that drawing on the computer is not equal to drawing with a pencil. There are differences, but for the purposes of developing conceptual studies, the computer provides all the visual information needed to move on to canvas or paper.

Just as the Impressionists learned to incorporate the camera in their creative process, an artist today can learn to use the computer as a new creative tool that has unlimited flexibility. And because the revisions can be made so quickly, the artist can take time to explore many more directions than he ordinarily would with sketches or photographs alone.

The computer will help you overcome the roadblocks to setting up a successful painting and will stimulate your creative juices as well. Always remember, you can make countless "mistakes" until you are satisfied because they are so easy to edit. Best of all, it will reduce your fear of making mistakes, which gives you that much needed confidence and frees your mind to create your own personal statement.

Artists are always searching for new and better ways to produce artwork. Most of today's youth learn the computer as part of their curriculum. It is only logical that many will end up using the computer for creative purposes. We, as artists, must come up with our own interpretations of what we are seeing or feeling through our intuitive senses. That's why we are artists. We create. The computer helps pave the way.

Techniques and Tools

In this section are several examples of some of the favorite software computer tools and how they are used. The authors used Adobe Photoshop to create their images, but any similar software could be used to accomplish the same tasks. We have tried to provide our instructions in generic terms so you will be able to apply the concepts to your own software. Please refer to your software manual to determine similar tools and the exact steps required to accomplish these functions.

There are many more options in the various programs available to you than are shown here; we have tried to indicate the tools that are most useful to the artist. Keep in mind that there is often more than one way to accomplish a task in the programs. Once you learn the basics, your creativity will be limitless.

TOOLS OF THE TRADE

Shown are toolbars from Adobe Photoshop and Photoshop Elements. If you are using another software program, the tools may be found in different toolbars or windows and may be labeled with slightly different names.

PHOTOSHOP

RECTANGULAR/CIRCULAR MARQUEE — MOVE
LASSO — MAGIC WAND
CROP — SLICE
AIRBRUSH — PAINTBRUSH/PENCIL
CLONE/PATTERN STAMP — HISTORY BRUSH
ERASER — LINEAR GRADIENT
SMUDGE/BLUR/SHARPEN — BURN/DODGE
PATH POINT SELECTION — TYPE
PEN/BEZIER POINT — LINE/SHAPE
NOTES — EYEDROPPER/MEASURE
HAND — ZOOM
FOREGROUND COLOR — BACKGROUND COLOR

PHOTOSHOP ELEMENTS

RECTANGULAR/CIRCULAR MARQUEE — MOVE
LASSO — MAGIC WAND
CROP — TYPE
CUSTOM SHAPE — GRADIENT
AIRBRUSH — PAINTBRUSH
PAINT BUCKET — PENCIL
ERASER — IMPRESSIONIST BRUSH
BLUR — SHARPEN
SPONGE — SMUDGE
RED EYE BRUSH — DODGE
CLONE STAMP — EYEDROPPER
HAND — ZOOM
FOREGROUND COLOR — BACKGROUND COLOR

Photographs and thumbnail sketches are often used in an artist's work. You will learn to manipulate them using the software. Part of the beauty of using the computer to test ideas is you can easily undo a step or steps or save various versions and decide later which one you want to use for your painting. You are free to experiment without ruining your painting, so don't be afraid to try all types of options. With practice, using the tools will become second nature, just like using a pencil or paintbrush.

HOW TO GET AN IMAGE INTO THE COMPUTER
Before using any tools, you will first need to get your photo or sketch into the computer. If you are using a digital camera, connect your camera to the computer, download the images to the desktop using your camera's software, then open the file using Photoshop. If you are scanning your image, place your photo or sketch in the scanner. Follow the instructions in the scanner's manual to scan the image into the computer, then open the file using Photoshop.

Useful Photoshop Tools

AIRBRUSH TOOL

Before *After*

You use this tool much as you would an airbrush for painting glazes. You specify the color in the Color Palette, determine the opacity, and glaze the color over a shape. Here, we have glazed a yellow color over the windows and side of the house.

CLONE TOOL

Original *Clone (partial)*

Cloning is an invaluable tool for filling in areas, shapes, or entire objects. You specify the area that you want to clone *from*, then move to the area that you want to clone *into* and fill the area with a duplicate of the original by holding and dragging the cursor over that area.

COLOR PICKER AND PALETTE

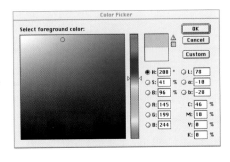

By clicking on the Color Box in the tools (Foreground or Background) a Color Picker window is opened. You can also access this window from the Color Palette. Using the Eyedropper tool to click on any color in your image, you can see exactly how saturated a color is or where it falls on the grayscale. Using this palette to visualize a color will make you sensitive to its location on the color wheel. You can also select a color directly from the Color Swatches.

CROP TOOL

This tool is used to crop the edge of your image. You can use either the Crop tool or the Rectangular Marquee tool to accomplish the same thing. One way to first test if a crop is going to work visually, is on a new layer (see *Working with Layers*), crop the area you are considering, then Inverse the selection, and fill it with white as an instant test mat.

EYEDROPPER TOOL

By holding this tool over any color of your image and clicking, you load your palette for the Pencil, Paintbrush, or other tool with that color.

GRADIENT TOOL

Select two colors for a gradient, then select an area, and fill it with a gradient of those two colors by holding and dragging the mouse over the shape with the Gradient tool. With a little practice, you can vary the proportion of each color in your gradient. This is an especially invaluable tool for applying gradient skies.

LASSO TOOL

You may select or "lasso" an object or shape by holding and dragging the mouse while drawing around it. (See *Making Selections* below for more details.)

Before *After*

MAGIC WAND TOOL

By clicking a value, color, or shape with this tool, the Magic Wand selects all pixels of similar value or color. You will find you use this tool often to make selections, especially in combination with the Lasso tool to make complex selections. (See *Making Selections* below for more details.)

MOVE TOOL

You can easily move a selected object or shape (see *Making Selections*) to a new location with the Move tool. Then you can fill in the empty space where the object was moved from, by cloning or painting in the background color around it.

PAINT BUCKET TOOL

Using this tool is a quick way to fill a selected shape with color or a pattern. You may also fill a shape by using the Fill command.

PENCIL OR PAINTBRUSH TOOLS

Before

After (using the Paintbrush tool)

Much like a normal pencil or paintbrush, you can specify various widths and edges of the Pencil or Paintbrush. You can also specify the texture of the brush or pencil by using the Dissolve, Color Dodge, or Color Balance modes. You use the mouse to manipulate your tool. There are also computer pen and pencil pads available for sketching, such as a Wacom pad, which can replace the mouse.

SMUDGE TOOL

Before

After

This tool is used to soften edges of certain shapes, much like you would do with your brush or finger on a painting.

ZOOM TOOL

Before

After

Select the Zoom tool and hold and drag over the area you want to zoom into. This function allows you to see detail in a shaded area or a building or object in the distance. If you need to keep the detail for reference, copy and paste it into a new file. Then scale it as large as needed to work, and apply the filter "Sharpen Edges" for even more detail. It will provide excellent reference material while you are painting.

Transformations

A transformation may consist of moving, erasing, copying, or altering color or value of an image. Transformation commands can be found at the top of your screen in pop-down menus.

MAKING SELECTIONS

In order to transform color, value, or texture in certain areas, you must first tell the computer what area you want to apply the transformation to. There are several ways to select or highlight an area:

- Lasso Tool
- Magic Wand Tool
- Rectangular or Circular Marquee Tool

By holding down the Shift key, you can add to your selections. For example you could pick a color shape with the Magic Wand tool, hold down the Shift key, and add to the selection by using the Lasso tool. To subtract part of the selection, hold down the Option key (Mac) or Alt key (Windows). The resulting selection may be filled with a color or texture or deleted.

You can also add to a selection by using the Grow or Similar commands. You will discover other ways to make selections as you progress with your work.

A little trick to help you better determine a value or color as you are transforming it is to turn off the Selection Edges (or marching dotted lines indicating your selection). Just remember that they are still selected until you Deselect them, even though they might be hidden.

When you make a complicated selection, be certain to save it in the Save Selection command in case you may need it again. You then can reselect it with the Load Selection command.

BRIGHTNESS/CONTRAST, HUE/SATURATION, LEVELS AND CURVES COMMANDS

After selecting a shape or layer, you can alter its value or color by playing with these commands. With more experience and practice, you can discover ways to alter a selected color or all the colors at once.

POSTERIZE COMMAND

For a painter, this command is invaluable for determining simple shapes. It works much like squinting at an image, by deleting the detail and determining the value. You can specify how many levels of value you wish to view the image in.

GRAYSCALE MODE

The software offers several modes and formats in which to view your image, but the one that artists will often use is the Grayscale mode. Although you might be working with color, you can instantly turn your image to grayscale to help you better determine the value of the color, and to see if your shapes are working in your composition. You may convert your image to grayscale in the Grayscale mode command or Desaturate command. The Grayscale mode combined with the Posterize command is a great way to view your image as a thumbnail sketch.

COPYING AND PASTING

To move an object or shape, you first select it then copy and paste it to a new location As an artist, you use this transformation a lot as you are redesigning your composition.

ROTATE, SCALE, DISTORT, AND PERSPECTIVE COMMANDS

An object or shape can be selected and any of the above commands can be applied to it. There are a variety of options available under these commands. The selection must be made first in order to apply the command.

How often have you looked at an image and wished that a branch was headed in the opposite direction. With the Flip Horizontal command, it can be done instantaneously. Sometimes, if you rotate your image, you can get a new vision of your composition. It helps you to see shapes, not things, to better determine if they are working in your design. After viewing in that mode, it can easily be returned to correct alignment.

Working with Layers

LAYERS PALETTE

The Layers Palette is a wonderful tool for the artist. It enables you to relocate an object anywhere on your picture plane. Think of the Layers Palette as a stack of clear acetates on which you have drawn various images and now want to visualize them together.

The demo on the following page shows that when you copy and paste an image (the sheep), it is automatically placed onto a separate layer with a transparent background so you can see the original image underneath. With the Move tool, you can move the object to its new location. Because it is now on a separate transparent layer, you can independently Scale, Rotate, Distort, Flip Horizontal or Vertical or change its color or texture to fit your design. Once you have finalized your design, you can reduce the size of your file by utilizing the Merge Layers command.

When you first start working with layers, you often get stuck because you are trying to apply a transformation while on the wrong layer. In the Layers Palette, the highlighted layer is the one you should be on to apply the transformation.

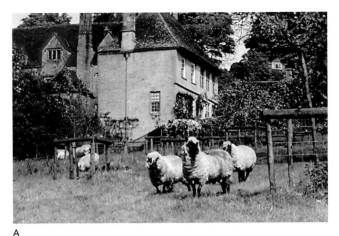

A

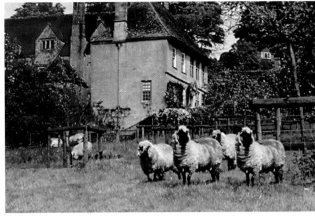

B

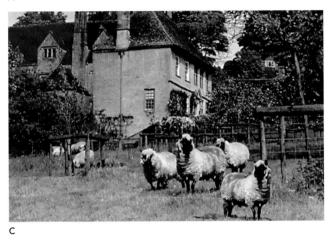

C

A *Original scanned image.*

B *The center sheep was copied and pasted onto another layer. Then, it was moved to its new location by holding and dragging it with the Move tool.*

C *In these same two layers, the identical sheep was flipped after copying it, applying the Flip Horizontal command, and moving it to a lower position.*

HISTORY PALETTE

The History Palette is one of those commands you wish you had while you are painting. With it, you can revert to any recent step in your design during the working session. Mistakes can be corrected instantaneously. Once you save the file, the history for that session is gone. This palette lets you experiment with any option without worrying about ruining your design.

Applying Filters

Filters are fun to play with to create various moods and textures of your images. With the advantage of the History Palette, you can test any filter, but then revert back to the original image if you do not like it. By using a combination of filters and their controls you can achieve a variety of effects. Filters work much like texture techniques in a painting.

Some filters that have been used in the demonstrations in the book are: Find Edges, Blur, Noise, Sharpen Edges, Paint Daubs, and Sponge. There are many other filters for you to test and create. Remember, in order to apply the filter to a certain area or shape, you must first select it.

Before and after applying the Poster Edges filter.

Determining the Size of Your Canvas/Paper and Your Computer File

Throughout this book, you will find a lot of discussion about the size of a finished painting or the size of a computer file. Why do artists need to know this? Just as it would be a mistake to do a wonderful thumbnail sketch and then not relate the dimensions of your painting to the relative size of your thumbnail sketch, you need to properly size your computer file in relation to the finished work of art.

There are two ways to determine the size of your painting:

- Retain the proportions of the photograph or your computer file and cut the canvas/paper to those proportions.

- Use a predetermined canvas/paper size and scale your computer file to match the proportions.

DETERMINING CANVAS OR PAPER SIZE TO RETAIN PROPORTIONS OF YOUR PHOTOGRAPH

If your computer image file size is 5" wide by 3.6" high, the ratio of width to height is 1.38. In Photoshop, you can see the size of the file by the Show Info Palette or Image Size window. If your canvas or paper size is 24" wide, then the height would be 17.3" high. Your dimensions can vary slightly, but you should keep the proportion fairly close to retain the feeling of the image.

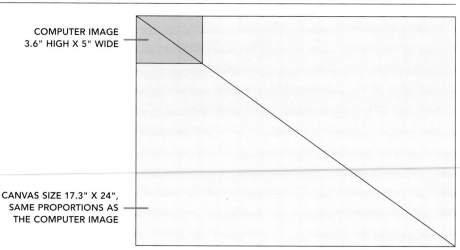

COMPUTER IMAGE 3.6" HIGH X 5" WIDE

CANVAS SIZE 17.3" X 24", SAME PROPORTIONS AS THE COMPUTER IMAGE

DECIDING WHERE TO CROP YOUR PHOTO, FOR A PREDETERMINED PAPER OR CANVAS SIZE

Let's say you have scanned a 4" x 6" photograph and you have a 16" x 20" canvas that you want to use for your painting. Your computer sketch must end up with the same proportions as the canvas, so how large should you make the computer sketch?

Determine the ratio of the width and height of the canvas size: 20" divided by 16" = 1.25. This means that your width divided by the height is a 1.25 proportion.

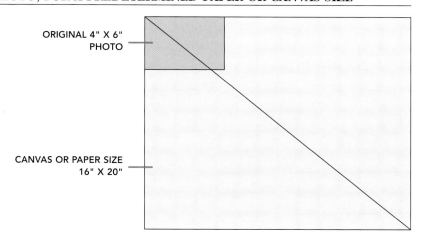

ORIGINAL 4" X 6" PHOTO

CANVAS OR PAPER SIZE 16" X 20"

Height Priority

If you want to utilize the full 4" height of the image, you will need to crop the width to retain the proportions of 1.25 (4" high x 1.25 = 5" wide).

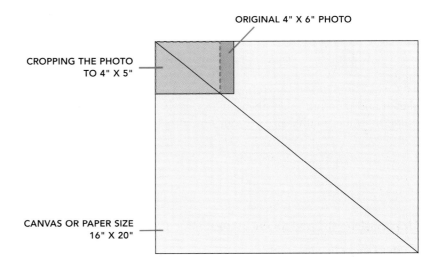

ORIGINAL 4" X 6" PHOTO

CROPPING THE PHOTO TO 4" X 5"

CANVAS OR PAPER SIZE 16" X 20"

Width Priority

If you want to utilize the full 6" width of the photo, then you need to make the computer file taller to keep those proportions (6" divided by 1.25 = 4.8" high) by adding .8" to the height of the computer file.

After you enlarge the computer file, you can move the image to any placement you wish within the new frame, then fill in the excess blank area with some surrounding texture or color. Your computer file is now the same proportion as your canvas.

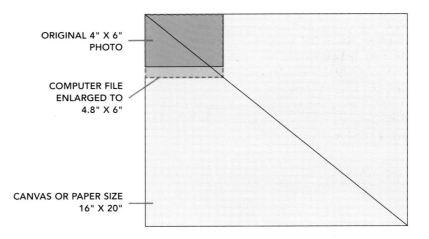

ORIGINAL 4" X 6" PHOTO

COMPUTER FILE ENLARGED TO 4.8" X 6"

CANVAS OR PAPER SIZE 16" X 20"

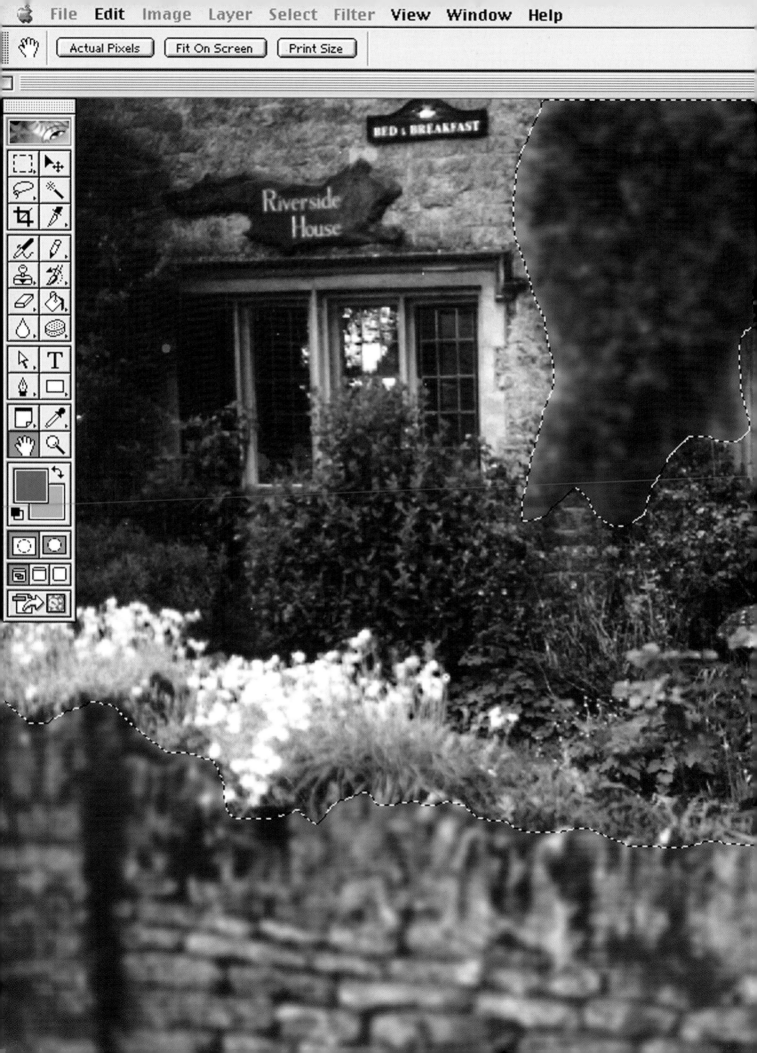

Working with One Photo

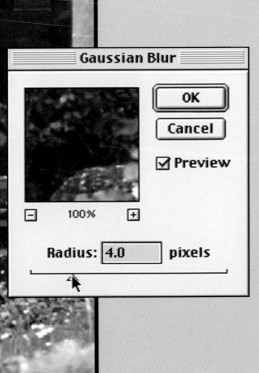

Gaussian Blur

OK

Cancel

☑ Preview

100%

Radius: 4.0 pixels

Developing Value Studies

"Cotswold Burgundy Door" by Jann Lawrence Pollard
watercolor, 20" x 20" (51 x 51 cm)

I took this photo in Bourton-on-the-Water, a Cotswold village (Image A). Back in my studio, I remembered that what caught my eye was the solid feeling of the burgundy door against the textures of the red foliage and the cottage. The textures of the stone on the old cottages reflected years of wear from the elements. I have spent a lot of time trying to emulate these textures on paper.

Often, I apply textures in several layers of paint to try to get the effect I want. When playing with these effects, I constantly keep in mind the value that I am working with, or the painting simply won't work. This is because I paint shapes of color and texture, rather than objects, which makes it difficult to gauge the shapes' relative lightness and darkness. Next to a lighter one, a color can look darker than I'd like it to be. Therefore, while painting *Cotswold Burgundy Door,* I often referred to the Color Palette in Photoshop to check a color's value and saturation. As other colors are painted around it, it no longer appears too dark. This step eliminates the need for traditional value and color studies.

I began by looking at the quick color notes in my sketchbook, which helped me to recall why I wanted to paint this scene. The lighting in the photo was fairly flat, so I would have to rely on my memory of the color and textures I had seen to create the feeling I wanted. I proceeded to make the necessary value and color studies on the computer.

1. I started with some compositional adjustments. First, I cloned the white flowers on the far left of the original photo to a new location towards the center because I intended to crop the far window off, leaving a square format to emphasize the burgundy door as the center of interest. The new placement of the white texture of the flowers added a foreground depth to the image. The triangular reflection in the window left of the door created too much interest, so I cloned the reflection from the window on the far left, which was softer. (Image B)

2. While painting, you can zoom into areas of an image to identify shapes and colors with the Zoom tool. Your eyes might have seen those colors when you took the photo. Zooming in on them helps you to recall them. Photoshop allows you to "pick" or isolate a certain color and enlarge it, which

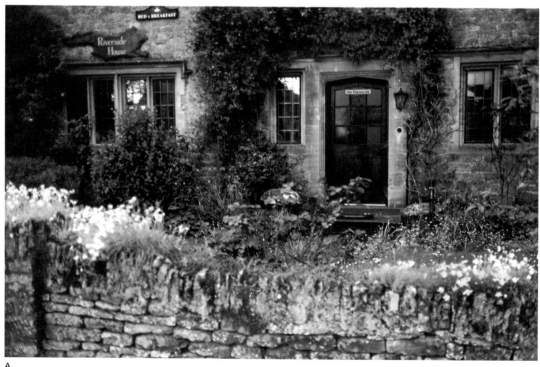

A

allows you to gauge how light or saturated it is. I repeated this technique often to experiment with many subtle variations of color in the branch with burgundy leaves in front of the doorway. (Image C)

3. Because I wanted less detail on the foreground stone wall and vines, I used the Lasso tool to select them. Then I applied a Gaussian Blur filter. I mentally registered that later I would paint these shapes loosely and with little detail. When

an image has a lot of texture and detail, it should be balanced by some less defined areas, on which the viewer's eye can rest. (Image D)

To draw attention to the center of interest, I painted some bright, yellow flowers directly below the door and cloned and painted blue flowers to its right, which added further texture and color. Some of the pale purple flower shapes (lower right) were softened by applying the Blur filter.

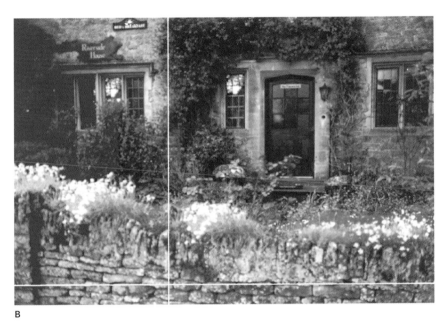

B

A *This photo of a Cotswold cottage lacked depth and a center of interest.*

B *The photo was cropped to a square format to help direct the viewer to the burgundy door.*

C *The color and textures in the flowers and the burgundy-colored branch are emphasized by adjusting their values and saturation levels.*

D *The foliage in the upper left corner was selected and the Blur filter was applied to soften the edges.*

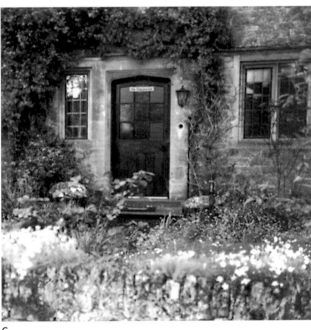

C

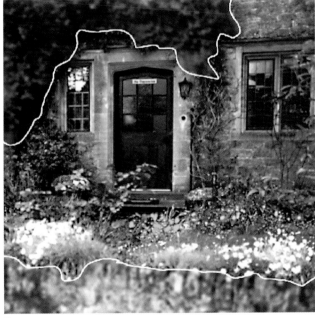

D

4. At this point, I changed the values by lightening the shadow areas in the Levels dialog box by dragging the sliders. I also increased the overall contrast and brightness to give it that final "pop." (Image E)

5. In the final painting (Image F), I followed my computer sketch fairly closely. Since I paint shapes of color and texture, I rely on the Color Palette to help me judge the colors' value and intensity. As other colors are painted around it, it no longer appears too dark. I could not paint in the manner that I do, unless I had done a similar value and color study.

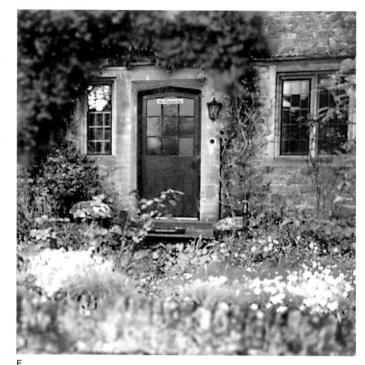

E

E *Now the viewer's eye is redirected to the burgundy door and branch with these compositional adjustments.*

F *The painting closely mirrored the final computer image.*

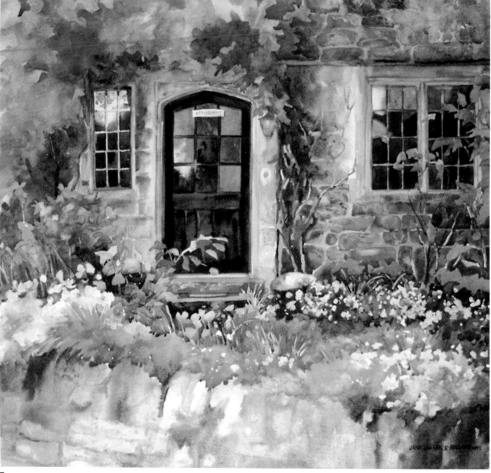

F

Bringing Back Lost Colors

"Cobalt Colors of Provence" by Jann Lawrence Pollard
watercolor, 21" x 29" (53 x 73 cm)

Among the photos I take on my travels, there are often some disappointing prints, especially when I fail to properly address the lighting with my camera settings. For instance, when there is a strong backlight, as in this photograph of a village in Provence (Image A), the shadows are too dark and the highlights are too light. In order to get the detail I want, I have to take two separate photos, with the exposure set for either the shadows or the highlights.

When traveling, most artists, unless they are also professional photographers, only take photos with automatic settings, which often results in prints with the dark shapes too black and the light shapes void of detail.

In my sketchbook, I noted the wonderful colors in the scene—salmon, raspberry, and cobalt purple, my name for the cobalt blue-purple shutters that you see everywhere in Provence. Although none of those colors came through in the photo, I knew I could revive them on the computer.

Because of the extreme contrast between the shadows and highlights, I had to work on each area separately. If I tried to bring out lost detail over the entire image, I would have blown out the light colors and lost some detail in the dark areas.

A *In this backlit photo, a lot of detail is lost in shadows that are too dark.*

A

1. The first step was to lighten the shadows. To do this, select the shadow areas by choosing the shadows with the Color Range command. This opens the dialog box (Image D) that allows you to select areas of colors or values, such as reds, yellows, and greens, or Highlights, Midtones, and Shadows. This is done by moving the Eyedropper over the range of colors you wish to select. Remember to save your selection in case you need to return to it. Then, with the shadows still selected, to bring out the middle values and lighten the selected area, go to the Levels command and move the middle value slider to the left. This lightens the shadows in the selected areas. (Image B)

Next, I adjusted the brightness and contrast levels to bring out some of the detail lost in the highlights. To select just the highlights, first select the shadows that you have saved and then choose the Inverse command. Now you can play with the Brightness/Contrast and Hue/Saturation commands.

2. Here, the colors and values started to come to life. I selected the area of sky, and with the Gradient tool I applied a gradient fill of a manganese blue and a cobalt purple color to bring back some of the color that had been lost. Clicking on the Gradient tool opened the Options bar, from which I

could choose gradient styles and other options, such as opacity. To apply the colors, I dragged the Gradient tool across the selection. With practice, you can vary the amount of each color in the gradient you want to emphasize. (Image C)

The shadows on the right wall were wonderful, but they were too busy, so I simplified them by cloning some of the surrounding textures to fill some of the dappled shadow shapes, cloning from either the shadow or light textures of the wall. To see this more clearly, compare the shapes of the shadows in Image A with the simpler shapes of Image C.

3. I had a difficult time pulling some of the darks out of the green-

ery on the right wall at the end of the street, so I selected a dark green color and roughly painted in an indication of foliage with the Paintbrush tool (Image E). I continued to adjust the saturation, hue, brightness, and contrast until they came close to the scene I remembered.

Referring back to my sketchbook, I recalled the wonderful raspberry and red flowers on the shrubbery, playing against the salmon color of the building. In the photo, you can hardly see these flowers. So, I emphasized the colors by selecting a brighter color in the Color Palette and painting in a few flower shapes with the Paintbrush tool. To emphasize them even more, I also enlarged the flowerpots by painting them larger with the Clone tool.

B *The Photoshop Levels window with a histogram indicating the values of your image. Refer to your software manual for more information on histograms.*

C *Compare the shadows on the right building with the shadows on the original photo to see how the shapes were simplified by cloning some of the texture of the wall.*

D *The Photoshop Color Range window that indicates the masked shadow areas (black shapes) that have been highlighted.*

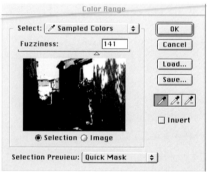

D

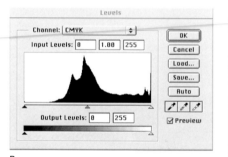

C

When I finally worked on the actual painting (Image F), I had fun splashing on the textures and colors because, as long as I stayed relatively within the same value range and shape, I knew the painting would work. The digital studies freed me to be creative with the application of paint and the selection of color. I varied the colors, but I kept the values fairly close to my digital study. I like to paint loosely with more of an impressionistic style rather than copying the photo exactly. I could not paint like this without relying on these value studies whether done on computer or in my sketchbook.

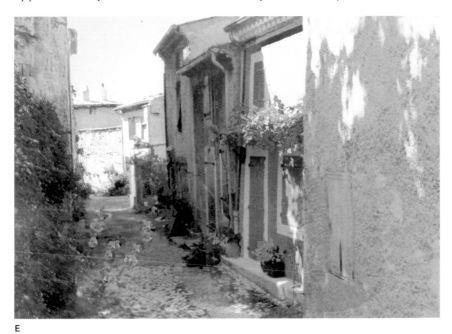

E

E In the final image, the viewer is now directed to the bright building on the right and then invited to continue down the road.

F The feeling of the cobalt colors was brought closer to the actual colors of the "plein-air" scene.

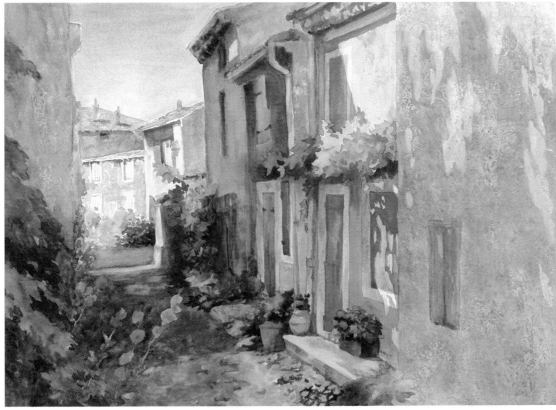

F

Developing Color Themes

"Sounds in the Dark" by Jerry James Little
watermedia, 20" x 16" (51 x 40 cm)

Applying feeling to a subject or image is not always easy to do, but a painting with emotional content will be many times stronger than one without. With some subjects it is easier to feel an element of emotion than with others. This can apply to any subject matter, be it flowers, landscapes, or figures. Often we go to an art exhibition and wonder why one painting wins an award over one that is technically better. There is no easy answer to that question, except to say that the award-winning painting may convey a strong feeling that was developed by the artist's knowledge of that subject, and the jurors felt that emotion.

Music is a topic that will always create a mood. As a musician, I have always been interested in the emotion of music, particularly jazz. I have been around musicians for many years and like fine artists, they are expressive and creative people. I had always thought it would be fun to do a series dealing with these artists. Watching a musician play, you can't help being captivated by the expressions and feelings they convey. This is what I hoped to capture in my mixed media paintings. The title for this painting came to me as I developed dark color values that seemed to create a stage for mood music.

I had been collecting photos for some time in the San Francisco area, and decided that using the computer to start this series would be great fun and a challenging experience. The trumpet player (Image A) was part of a group of musicians playing in a club. I decided to feature him standing up instead of sitting in the chair.

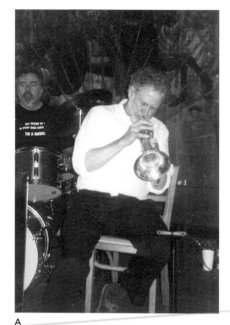

A

B

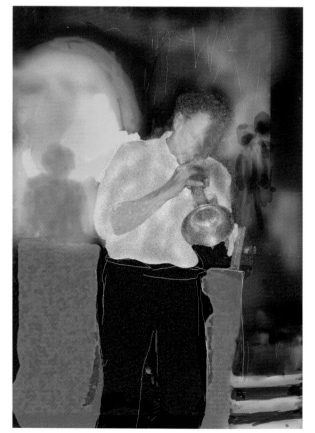

C

A *This photo was too busy and it lacked the moody colors I wanted.*

B *The background was simplified and the focal point was made stronger by further emphasizing the trumpet player.*

C *Here, I roughly experimented with various colors to create the mood I wanted.*

1. In Image B, I sketched in his legs with the Pencil tool and then filled in the legs with white so that I could better see my values. Then, to strengthen the design and also to create depth and mystery, I decided to separate him from the main band by drawing and painting some shapes behind him using the Pencil and Paintbrush tools.

2. In Image C, I wanted to create an environment for the soft music that would give the feeling of a nightclub scene. I started working in the background with suggested shapes and values and added various warm colors. I hoped to capture a certain mood by establishing a color theme of dark values for all colors. The drummer on the left was deleted and replaced with only an indication of a figure in the background. A suggestion of two figures on the right side was drawn in using a Paintbrush tool. A Blur filter was applied to the highlighted figure to soften the edges. I wanted to also experiment with the color of the trumpet player's clothing, so he would fit in with the color scheme. Using the same colors as the rest of the painting, I selected each piece of clothing and adjusted the colors in the Color Balance Palette. At this point, I liked the feeling of this image and decided to start painting.

3. In my painting (Image D), I continued to work further from Image C. The groundwork had been done, so all I had to do was continue on with this format. This process consisted mainly of refining and adding colors, as well as more texture. I decided to remove the stairs that I had added in Image C, as they did not add to the composition.

My work on the computer gave me the extra visual references for color and value to help me achieve the strong emotional content that I was looking for. The end result was a much stronger painting.

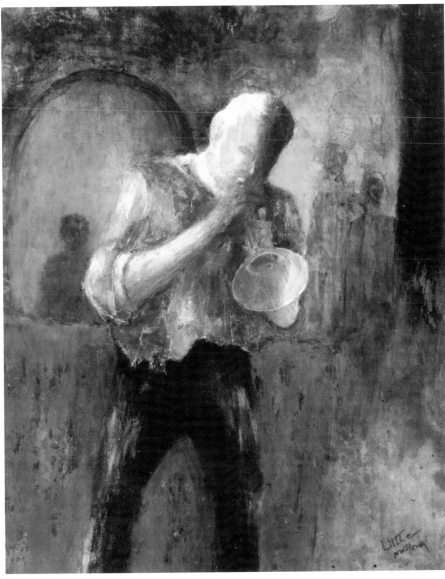

D *Now the trumpet player is surrounded by the feeling of a nightclub, enhanced by a deeper sense of space and mood.*

D

Bringing Out Lost Detail

"Boats in Fog" by Catherine Anderson
watermedia, 22" x 15" (56 x 38 cm)

Catherine Anderson paints to convey the peace and wonder she feels when she puts her brush to paper. During those hours, she returns to the awe and awareness of nature she knew as a child.

Because her paintings are so delicate, she usually begins by doing a light sketch on watercolor paper. To this, she applies masking fluid to preserve the lighter areas of the painting. Next, she starts her signature wash technique of applying layer after layer of color. In between the layers of color, she may rub off the masking fluid, so she applies more masking fluid as she continues with her washes. While building up a glow with layers of paint, she also layers the masking fluid to create more texture. This can be seen in the soft, rippling waves of *Boats in Fog*.

Anderson has become quite well known for her ability to capture the atmosphere of fog using a multitude of glazes. She wanted to paint from this photo of boats in fog, but the boats were so enshrouded in fog and so small, there was little detail from which to work. (Image A)

1. First, she cropped the photo to zoom in on the boats and make the image vertical. The portion of the large dock (seen in Image A on the left) was cloned with some of the surrounding water over it. Next, she needed to bring out the detail of the boats. After zooming in on them, each boat was selected individually and the Brightness and Contrast levels were adjusted. To bring out even more detail, a filter was applied

that sharpens images, which is called Unsharp Mask in Photoshop. (Image B)

Anderson then made subtle color adjustments to the fog and water. Because of the complexity of the gradient colors in fog, if you use the Magic Wand to make the selection, only a few pixels will be selected (only the one color). Instead, you select all of the boats at once by holding down the Shift key and using the Lasso tool to select some of the boat areas and the Magic Wand tool to add to the selections. When all of the boats are selected, use the Inverse command to automatically select the entire fog and water shape all at once. When you do a complicated selection like this, be sure to save the selection so you can use it again should you need to.

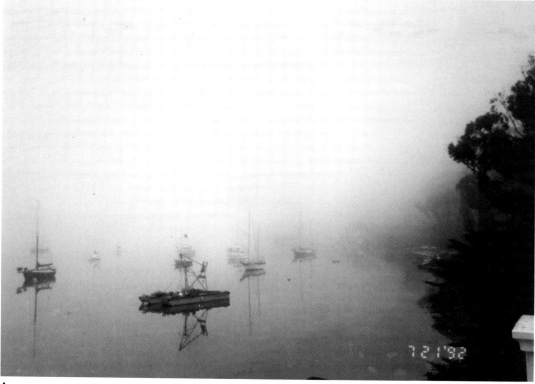

A *Catherine wanted to paint the boats in the fog, but they can hardly be seen in this photo.*

A

2. To create more depth, she had to bring up the warmth of the fog color. With the Gradient Fill tool at a low opacity, a transparent soft glaze was applied to the area, similar to the way in which she paints. By applying several glazed colors a clear transparency is created, much like fog. She also indicated a few soft, rippling waves in the foreground, to create even more depth. To do this, in the Paintbrush Options window, she played with the Paintbrush tool, applying the wave shapes with softer edges and transparency loaded on the brush. Some of them also were painted in the Dissolve mode, which removes some of the paint from your brush, much like a dry brush effect.

Returning to the boats selection (which was saved under Save Selection), the brightness and contrast were adjusted to intensify them again, because as the fog and water value and color shifted the boats now needed to be brighter with more contrast. To indicate activity, a few bright colors were painted on the boats and buoys.

Often, Anderson finds it difficult to paint from a photo. But on screen, she was able to see faint colors and enhance them, solving many painting problems in advance. Because of the way she paints in a multitude of layers, the combination of these transparent glazes produce new colors that cannot be achieved any other way.

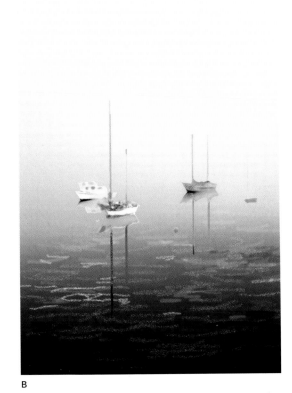

B

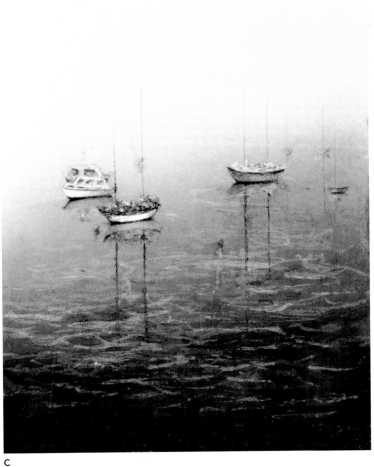

C

B *By zooming in on the boats and enhancing their detail, a new vertical image was created.*

C *In her final painting, Catherine was able to achieve the effect of fog she wanted by applying a multitude of glazed layers of paint. She knew exactly where she was headed with each glazed layer from her computer sketch.*

Enhancing Shapes and Shadows

"No. 6 Garage Door" by Dick Cole
watercolor, 27.5" x 19.5" (70 x 49 cm)

At a National Watercolor Association Exhibition a fellow watercolorist studied Cole's paintings and concluded that he was a value painter. Cole agreed that he likes to work with light and shadow to dramatize the common subject. He usually works from photos and black-and-white thumbnail sketches to establish the design parameters. By first applying his darkest value in his sketches, he is able to establish the range of values he wants to achieve.

One day, Cole opened a garage door and was struck by the strong design elements and value relationships on it. The photo he took of it was perfect to experiment with on the computer (Image A). He simply wanted to alter values and colors to make the image more exciting.

1. First, he selected the pale blue sky with the Magic Wand tool and painted it a brighter blue. The blue was selected from the Color Palette and then the highlighted shape was filled with the Paint Bucket tool. Cole didn't want the van in the background, so he deleted it and painted the area in with a matching blue. The shape of the van was highlighted and the same blue paint color was filled in the shape with the Paint Bucket tool. (Image B)

2. He selected the sunlit part of the door with the Magic Wand tool and adjusted the color with the Color Balance command, increasing the level of magenta. This gave the color more warmth and empha-

sized the cast shadow of a basketball hoop. It was barely visible before he did this. (Image C)

Cole wanted to experiment with the width of the canvas. In order to widen the image to make the small triangle of light on the grass more prominent, he added some width to the file in the Canvas Size dialog box. He cloned some of the adjacent colors of the grass and sky. After testing a few crop marks, he decided to widen the image only slightly to accommodate that small triangle of light.

3. Next, he intensified the contrast of the number "6" on the garage door, using the Brightness/Contrast dialog box. The worn red paint surrounding it was also brightened. (Image E)

4. Cole wanted to view the value pattern in only three values of gray in order to see the elements of his composition more clearly (Image D). To do this, it is best to save it as a copy, then, in the copy, change the mode to Grayscale. Then in the Posterize dialog box, indicate just three levels of gray. Another way to do the same thing is to use the Desaturate dialog box, then take it to three levels of gray in the Posterize dialog box. If you do not save a copy, be sure to revert back two steps in the History Palette to bring the color back to the image. From this viewing, he decided it was unnecessary to go any further with the composition. The simple design of Image E would work nicely for the final painting.

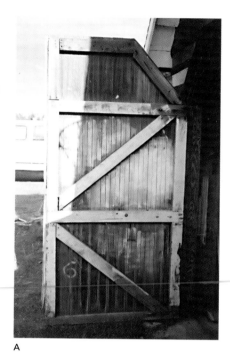

A

A *This image has strong design and value elements, but needed enhancing.*

B *The design was simplified by deleting the van on the left and adding warmer colors to the door to help guide the viewer.*

C *The canvas size was widened to test for more grass and sky on the left side.*

D *This image shows the design in three simple values to help the artist focus on the composition.*

E *The background has been simplified to basic shapes and the "No. 6" on the door has been enhanced.*

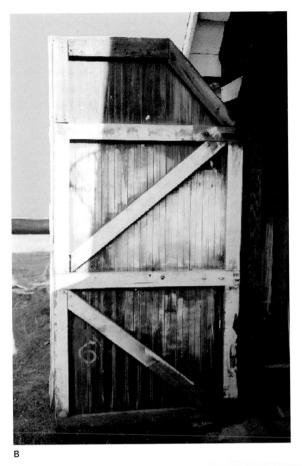

B

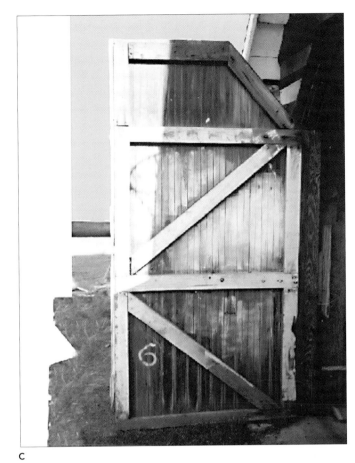

C

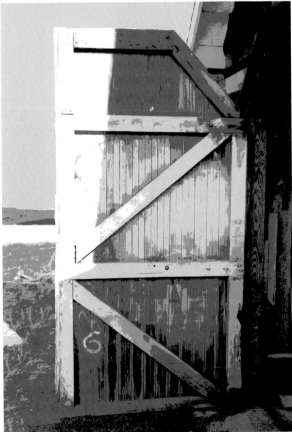

D

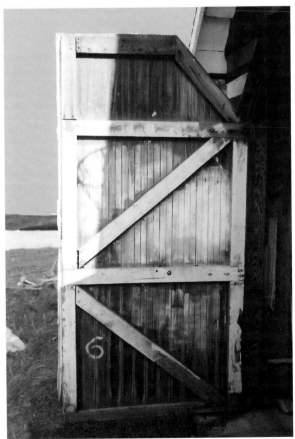

E

F *In the final painting the values were pushed a little more to enhance the simple shapes of his design.*

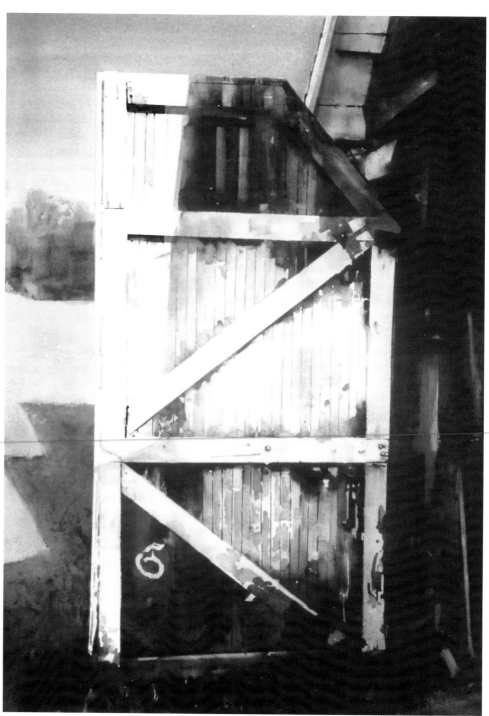

F

Dividing Picture Planes

"Cups in Repose" by Noriko Hasegawa
watercolor, 21" x 29" (53 x 74 cm)

Noriko Hasegawa has the ability to find beauty and strong design in simple objects. She saw the potential for an interesting design in an ordinary cup from her kitchen cabinet. Arranging four cups in an outdoor setting, she photographed an interesting pattern of light and shadow. (Image A)

1. After studying the pattern of light and shadow, she began by raising the cups on the right just to the point where the shadows met to connect the shapes. (Image B)

Then, Hasegawa decided to adjust the heights of the two background cups. She copied the rear, right cup shape and pasted it onto a new layer, so she could move it around independently of the other cup. She scaled it down so the top edge would not be the same as the front cup on the right. To scale the cup, she used the Lasso tool to select it, then scaled it in the Scale dialog box. To retain the same proportion while scaling, be sure to hold down the Shift key while moving one of the four corners of the highlighted shape. She repeated this action with the left background cup, except this time she scaled the cup larger.

To make the image come closer to the viewer, she cropped out the extraneous background. She had predetermined that she wanted to paint this image on a full sheet of watercolor paper, so we mathematically determined the proportioned dimensions of the crop lines in the computer file by maintaining the same width to length ratio. You can see exactly how large the Crop Marquee is by displaying the Show Info Palette.

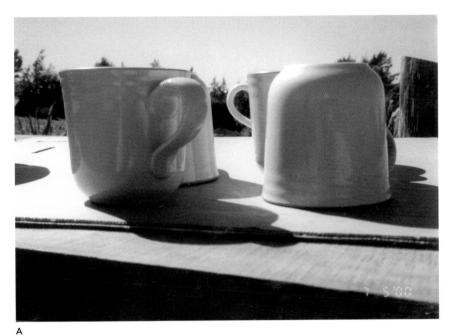

A

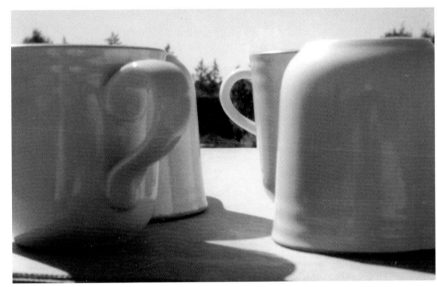

B

A *A photo taken of four cups in the backyard of Hasegawa's studio to take advantage of the natural light patterns.*

B *The image was cropped to focus more on the shapes of the value patterns.*

2. The cropping left a triangular area of light in the lower left corner. She cloned some of the shadow color over that corner to retain that large, simple dark shape. (Image C)

3. Next, Hasegawa wanted to change the background color to a gradated sky, so she selected the entire background and tested different colors. She selected the sky area with the Magic Wand and then held down the Shift key and used the Lasso tool to add the remaining background shape to her selection. Using the Gradient tool she applied a gradual transition of blue/gray and warm beige colors. Double clicking on the Gradient tool opened the Options bar, from which she could choose gradient styles and other options, such as opacity. (Image D)

The background was still too intense, so while keeping the sky selected, she created a new layer, selected a raw umber color in the Color Palette and applied various glazes of it in a very transparent mode by reducing the opacity, until she had the desired color. The file was then flattened into one layer in the Layers Palette using "Flatten Image."

She wanted to raise the horizon line of the beige surface, so she copied an area of it and pasted it onto a separate layer. Viewing the two layers stacked, she used the Move tool to move the horizon line (on the top layer) into the desired placement. To capture a sparkle on the cups, she brought up the contrast level slightly by choosing the Brightness/Contrast command.

In the finished painting (Image E), Hasegawa chose to make the shapes more asymmetrical. Instead of raising the left background cup as she had in Image B, she moved the left foreground cup to the left. All in all, the computer allowed her to visualize the final painting in less than two hours. In the past, this design process had taken her a long time by using black-and-white value studies and colored acetates.

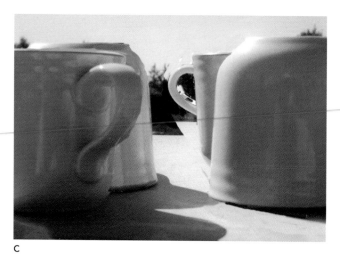

C

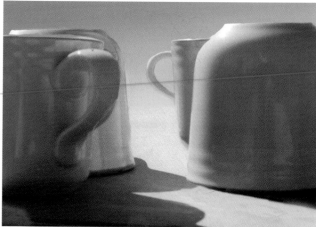

D

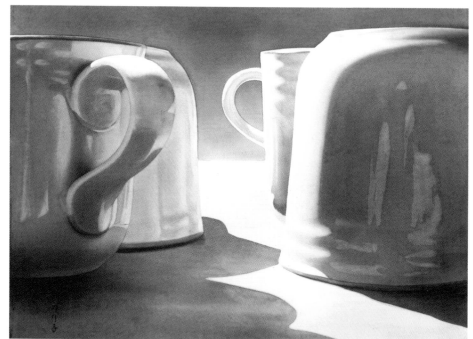

E

C *Some of the shadow color was cloned over the triangular area of light in the lower left corner.*

D *The background has been simplified and the value shapes have been connected.*

E *The values on the cups are enhanced even more in the final painting.*

Depicting a Distant Subject

"Segovia" by Charlotte Britton
watercolor, 11" x 15" (28 x 38 cm)

During her travels, watercolorist Charlotte Britton seeks out patterns in the landscape. She paints in her studio, using photos as a reference. To begin with, she does sketches to decide where to position elements on paper. The final composition is drawn onto watercolor paper. She establishes the values either in the sketch or on watercolor paper as the work progresses.

Out of several photos from her trips in Europe, she chose one of Alcázar, a sixteenth-century royal residence in Segovia, Spain. She wanted to paint this view of the town up close, but her photo did not show enough detail to recreate it accurately. To keep the mood of the profile of the old city, she had taken this photograph from a distance, so the rooftops of the new suburban buildings would be hidden from view. Because she was so far away from her subject, the photo was mostly of a barren foreground. (Image A)

1. First, she cropped the image in various places. You can create instant "tryout mats" on a separate layer by adding a layer in the Layers Palette, highlighting a mat shape, and filling it with white. These tryout mats will enable you to better visualize your finished painting. To do this, draw a crop rectangle with the Marquee tool,

then Inverse the selection and fill with white. If this tryout mat doesn't work for you, either use the Move tool to move it to a placement that does please you, or delete that mat layer and create another one with a different size mat. You can create more than one mat as long as you keep them on separate layers and then turn them on and off in the Layers Palette for viewing. Once you decide you are satisfied with the placement, you can crop the image and delete the mat layer. (Image B)

Although the original photo showed too much foreground, Britton didn't want to lose the foreground texture, so she eliminated some of the middle ground. The foreground area to be kept was roughly copied, pasted into a new layer, and moved over the unwanted area with the Move tool.

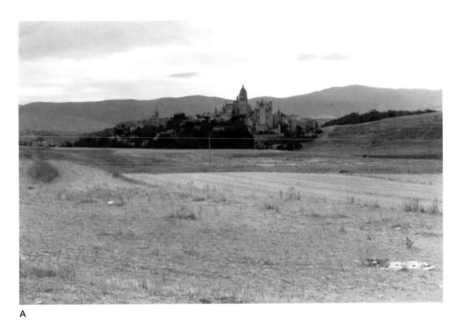

A

A *This photograph showed too much foreground and the village could hardly be seen.*

B *The image has been cropped in closer, some of the middle ground has been deleted, and the horizon line has been dropped to show more sky.*

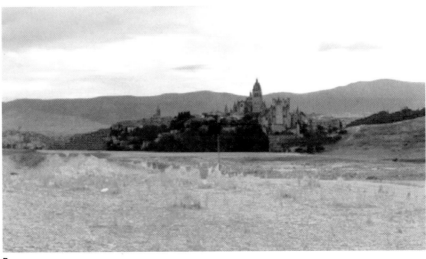

B

2. Britton wanted more sky and less foreground, so she cropped some of the bottom off and increased the height of the image at the top. To do this, using the Canvas Size command, you increase the canvas height of your computer file, then move your image to the location that you wish. In this case, she moved it to the bottom on the canvas. Then, she filled in the white space on top with dramatic clouds, partly by cloning colors and shapes and partly by painting with the Paintbrush tool. She used the Smudge tool to soften the edges of the clouds, making them appear more real. (Images B and D)

3. The Color Balance and Saturation was adjusted on the entire image. For more detail of the village, it was selected and the Unsharp Mask filter was applied. This has the same effect as painting hard edges. For contrast, the filter was not applied to the surrounding areas, which remained soft-edged or slightly blurred. The contrast of the buildings was also increased, which brought out the details even more. (Image C: A close-up of the village)

4. Finally, she decreased the contrast of the distant mountains, thereby pushing them further into the distance. This created more of an atmospheric perspective than seen in the original photo. (Image D)

Charlotte took home an enlarged photo of just the village (Image C) as well as the final computer image (Image D) to use while she did her painting. With the computer, Britton was able to enlarge the buildings and isolate some areas of the foreground that did not work in her composition. As you can see in the painting (Image E), Charlotte cropped the computer image a little more, changing the horizon line slightly.

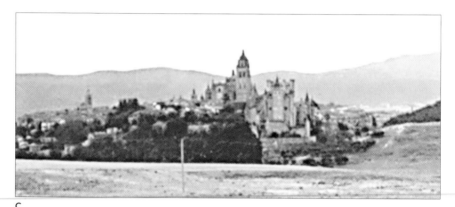

C

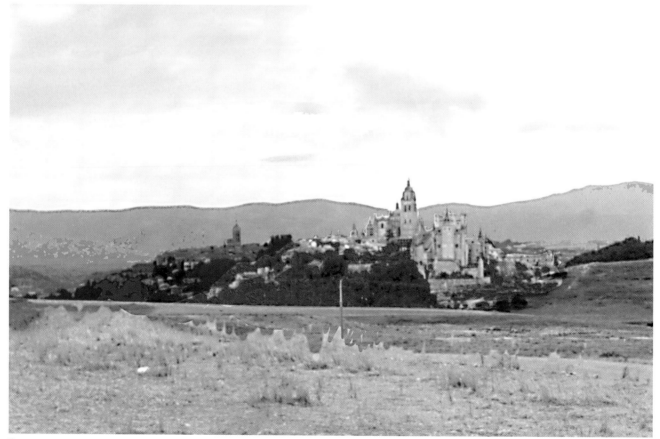

D

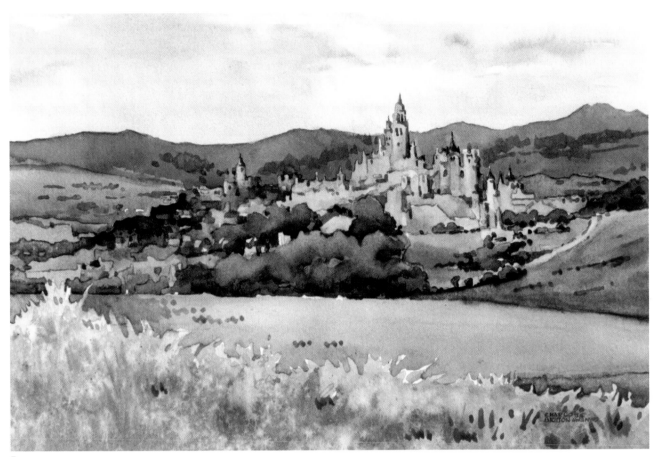

E

C *In this enlarged section of the village, the edges have been sharpened and the contrast levels increased to extract more detail of the village than the eye could see from the original photo.*

D *A greater atmospheric perspective was created by indicating less contrast and detail in the distant mountains.*

E *Britton has effectively brought her viewer closer to the old part of the village without losing some of the foreground interest.*

Working with Layers

Creating a Center of Interest

"Sun on Snow near Lake Tahoe" by Ron Ranson
watercolor and pastel, 13" x 17" (33 x 43 cm)

English watercolorist Ron Ranson is a confirmed landscape artist, who portrays skies, forests, rivers, and mountains in a loose impressionistic style. Whether painting on site or from a photo, he begins with a small sketch to determine composition and value pattern. This is done with graphite or charcoal, to prevent any temptation to go into detail. This way, he relies on as few strokes as possible. He is well known for his skillful use of the hake brush, a Chinese wash brush used for laying in large areas of water or color. Using this wide, flat brush helps him to lay in simple washes, void of detail.

These two photos were taken in Lake Tahoe, California, where Ron was teaching a watercolor workshop. It was May, and yet it snowed! Generally, he was pleased with the photo of the river (Image A), but he wanted to add a figure from Image B to be the center of interest.

1. First, he copied the figure in Image B and pasted it in Image A onto a separate layer. It is important to place the figure on a separate layer, so you can independently alter the scale and tone to match the original photo. The figure was too large, so he scaled it to look in correct proportion to the rest of the image. (Image C)

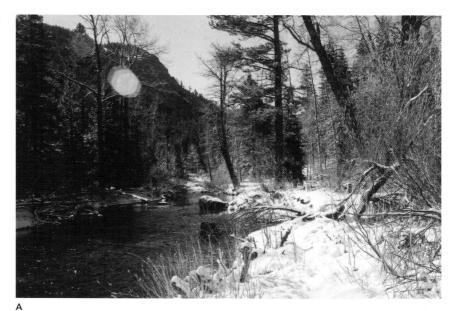

A

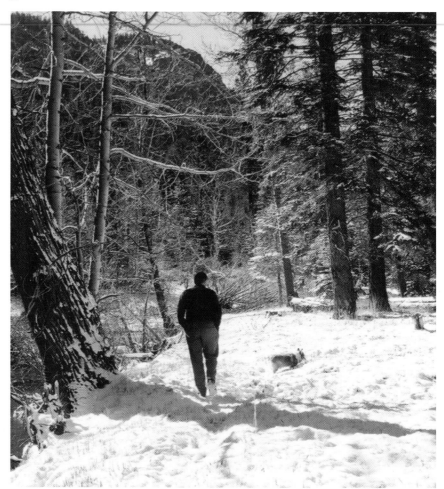

A *A photo that Ron took in Lake Tahoe, California, when he was teaching a workshop in May and it snowed!*

B *Another photo Ron took for the figure.*

B

2. To clean up the background of Image A, he deleted the camera flares by cloning matching background areas over it. He also deleted the dead tree in the center of the photo, by cloning some of the surrounding tree textures over it. (Image D)

To make the mountains recede, he smudged some of the extraneous detail with the Smudge tool, then, after selecting them, altered the contrast and brightness of the distant mountains to make them recede in the picture plane.

He also adjusted the brightness and contrast of the snow bank on the left, bringing out its shape and pulling the viewer into the painting. The green color of the trees was emphasized further by adjusting the color balance, especially in the highlights. You can adjust just the highlights in the Color Balance dialog box with the Highlights option also selected. A few brighter blue sparkles were added to the water.

3. Finally, to create more of an impressionistic feeling, he applied the filter called Plastic Wrap, which coats the image in shiny plastic, accentuating the surface detail. He then intensified the colors in the Brightness/Contrast dialog box. By doing this, he instantly created two different moods from which to paint—one realistic and the other impressionistic. It is fun just to play with the filters, or a combination of filters, to take your ideas to a new dimension—to some place you might not ordinarily go. (Image E)

Ron's final painting (Image F) was inspired by the impressionistic version. In order to bring up the highlights of the scene, he used pastels over watercolor. He was very pleased that design and value changes could be accomplished in seconds without traditional methods.

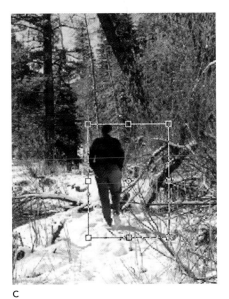

C

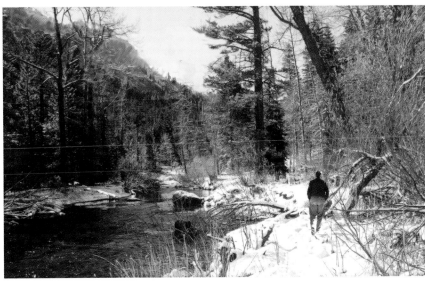

D

E

C *The figure was sitting on a separate layer, so it was selected with the Marquee tool and scaled to match its new location in the scene.*

D *The final corrected scene. The figure gives depth, scale, and a center of interest to the landscape.*

E *The same landscape scene with the Plastic Wrap filter applied to it.*

F

F *Ranson's watercolor painting achieved the same feeling as Image E without copying it.*

Staging a Composition

"Kelp Forest" by Steve Memering

oil, 36" x 48" (56 x 76 cm)

Steve Memering says he needs to be moved by a subject in order to paint it. To him a bowl of fruit just does not cut it. One motivation for his painting is to become totally immersed in the world of the painting itself. One of his favorite techniques for getting started on a project is to get about twenty sheets of big cheap paper, a bottle of India ink, and a big brush. He will make one big value sketch after another, using a fast, free style. This is his way of thinking out loud, before he actually focuses on the subject.

Steve has been a skin diver for over twenty years and has always loved the beauty of kelp forests. He had taken many underwater photos of kelp but could not seem to capture the light reflections he wanted. At the famous Monterey Bay Aquarium, he was able to take reference photos and catch the play of amber light through the kelp.

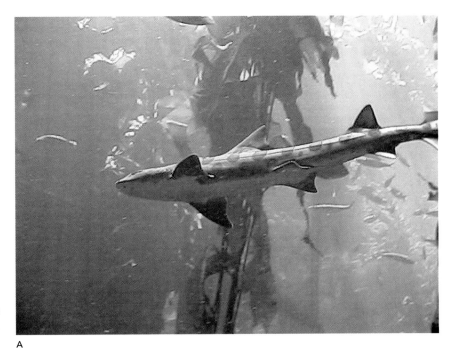

A

B

C

A *A photo of a shark in the Kelp Forest, Monterey Bay Aquarium, California.*

B *A close-up photo of some kelp with the light shining from behind.*

C *Detail photos of some fish.*

1. Steve thought he wanted to create this painting in oil on a canvas of 36" x 48", but wasn't sure exactly where he wanted to place the various images, so we created a blank canvas file that was 6" by 4" to give him space to work. Then we copied just the shark in Image A and pasted it into the new blank canvas file. We copied the entire kelp shadow in Image B and pasted it into the new file. We scaled and flipped it horizontally, and then moved this new layer underneath the shark layer in the Layers Palette so it would fill the space behind the shark. (Image D)

On this same layer, the white area to the right of the background area (the area on the right side of the shark) was highlighted and filled with a gradient of two colors of dark purple-gray and seawater teal. To soften the edge where the kelp shadow and the gradient shape met, we used the Airbrush tool with a soft brush, in the Color Dodge mode with a pressure of fifty percent. The Color Dodge mode softens edges (or erases them) and the Color Burn mode intensifies and darkens them.

2. At this point also, we checked the dimensions. Steve decided he wanted to retain the full 6" width. In order to retain the proportions of the canvas, the white canvas area at the bottom was filled in by cloning some of the background water and kelp over it. Next, Steve wanted to go back into Image A and bring in the kelp shadow behind the shark. We copied and pasted it onto a new layer in the master file and scaled it to fit the new image height. (Image F)

In the Layers Palette (Image E), note the placement of the Kelp Shadow Layer. The layer titled Background Test was a new layer created to test if he liked painting the background darker. By placing it on a separate layer, we could instantly view it in either mode before deciding to use it or not by turning the layer on or off.

Next, the two fish in Image C were selected, copied, and pasted onto a new layer. Each fish was scaled, rotated, and some of the fish were changed to black through the Color Balance and Contrast dialog boxes. See the layers in Image E: Large Fish 1, Large Fish 2, and Small Fish. The two fish in Image C were used to create all of the smaller fish

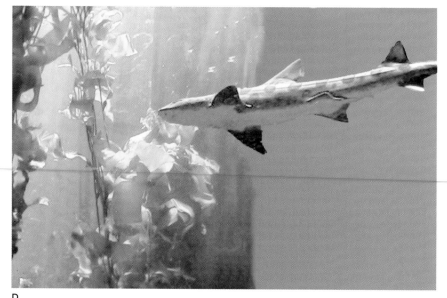

D

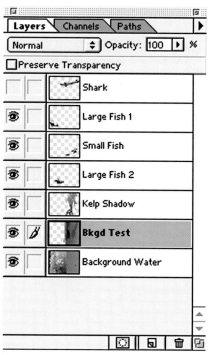

E

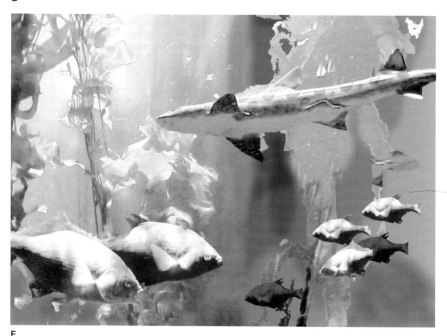

F

in the final image. Once their placement was determined, we merged those three layers together to keep the file size smaller. (Image F)

Steve wanted to deepen the value behind the shark, so we used the Airbrush tool filled with a dark violet gray color. Then, we highlighted the water behind the yellow kelp on the left and airbrushed a light violet (at about twenty percent opacity) to the water to warm it up a little. Another final tweak was made behind the small fish, by airbrushing the water with a purple gray glaze color, painting it a little darker.

Steve was already convinced that the computer was a powerful tool for the artist, having used it for his own work. He still made changes from the final computer image as he painted his final painting (Image G), but for him the computer brings his ideas to a high level of resolution. So many of the decisions he normally makes at the beginning of a painting are made by him on the computer. While the computer has changed some of the ways he paints, it still comes down to the most exciting part—to just paint and be free of the building process.

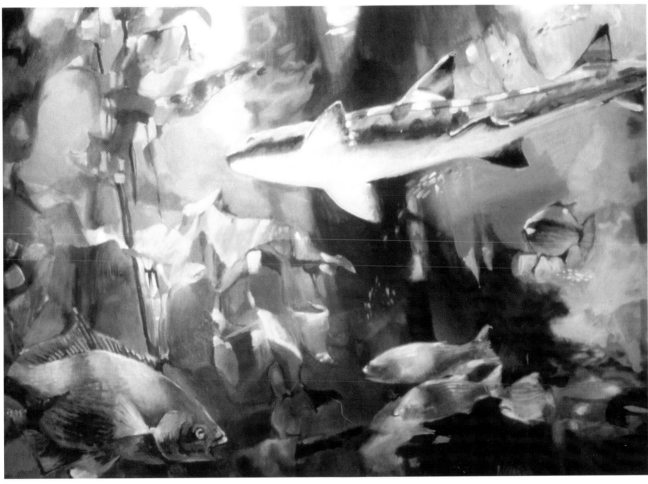

G

D *The shark in Image A and the kelp from Image B have been placed in the new file.*

E *The Layers Palette indicating the many layers of fish that were scaled, rotated, flipped, and moved around during the design process.*

F *A shape, such as the small fish, can be repeated several times, but with its color or size altered it looks entirely different.*

G *In the final painting, you can feel the depth of the ocean just as if you were a skin diver.*

Composing Background Elements

"Long Distance" by Judy Morris
watercolor, 21" x 29" (53 x 73 cm)

Judy Morris has always shopped flea markets to find discarded treasures that need a new home. The patina and surface textures of used items always catch her eye. When her house became full, she started searching the flea markets with her sketchbook and camera instead of cash. Judy is a retired art and calligraphy teacher, so items that include lettering are of particular interest to her. The French telephone booth sign sitting on a chair at the L'Isle sur la Sorgue antique market in France was irresistible subject matter for a painting. (Image B)

Judy's studio paintings start with an "inspiration photograph." In this case, it was the photograph of three chairs and the telephone booth sign. She adds images of other flea market items found by looking through her collection of photographs. Judy then completes a detailed drawing of the images on inexpensive butcher paper, cutting, pasting, and rearranging the objects until she is satisfied with the composition. She uses a light box to transfer the completed drawing to her watercolor paper.

1. After deciding that Image B would be her base image, we cropped it to a full watercolor sheet proportion of width to length of 1.38 (21" by 29"), which involved adding a little space to the top of the image to retain the full width of the image and those proportions, without cutting off any of the width. This was accomplished by increasing the height of the canvas. Judy did not want any of the background behind the three chairs so we carefully highlighted the background area and deleted it. (Image D)

A

B

C

A *A photo of some stacked paintings in an antique shop.*

B *A photo of some old chairs and a sign in an antique shop.*

C *A photo of a collection of antique frames.*

2. Judy wanted to bring the floral painting in Image A and place it behind the chairs, but it was missing the bottom piece of the frame, so we copied the top horizontal section of the frame, pasted it onto a new layer, flipped it vertically, and moved it into place to complete the missing part of the frame. (Image E)

3. The painting was scaled slightly larger and then placed behind the chairs by moving its layer to the bottom on the Layers Palette. It works much like a stack of clear acetates that you might have drawn on and you can move the shapes around until you like their placement. (Image F)

Returning to Image A, we copied the long, horizontal painting and pasted it into the main base file on a separate layer. Again, we had to move the layer to the bottom of the Layers Palette so it would be the furthest back in our image. In this same layer, Judy selected a navy blue color in the Color Palette and after highlighting the background, we filled it with this color.

4. Judy liked the shape of the oval frame in Image C, but it needed a painting in it. After copying the frame and placing it in our main file, we copied a portion of a painting to fill the oval frame (Image G) and moved it into place behind the chairs, exactly as the prior paintings had been done. (Image H)

D

E

G

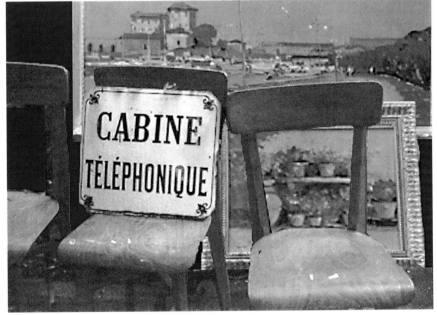

F

D The chairs and sign with the background removed.

E A close-up view of the small painting from Image A with the bottom part of the frame added.

F Two of the paintings have been placed behind the chairs and the background has been darkened.

G An enlarged photo of one of the empty frames with a portion of an Impressionist painting placed in it.

5. Judy wanted one more sign in her painting and didn't have an image from which to work, so we copied the "Cabine Telephonique" sign, scaled it longer, and inverted the color to give it a different look. The Invert command reverses every color in the selected image. Black becomes white, purple becomes yellow, green becomes red, etc. All of the layers but the top chair layer were merged together and the background was darkened. The brightness and contrast was increased on the original "Cabine" sign. The long, narrow painting was still too light, so it was highlighted and the Hue/Saturation dialog box was adjusted to make it work with the rest of the image (Image H).

Overall, Judy felt composition problems were quickly resolved by using the computer. The adjustments we made allowed her to immediately see the difference even minor changes in the position of objects would make to her composition. Color and value adjustments were equally convincing.

As Judy was drawing from the computer composition, she felt the activity behind the chairs needed to be simplified. (Image I) She elimi-nated the smaller painting and placed its more elaborate frame around the top horizontal painting. The lower sign was enlarged to simplify the space and the large scale of the letters gave more variety to the composition. Using the colors and values suggested in the oval frame, Judy invented a European scene that would blend with the image in the horizontal frame and work well in the space between the two chairs.

Judy's biggest surprise happened when she started painting. Because of her work with the computer, the color chord was predetermined and less adjustments needed to be made during the painting process. She is convinced that using the technology of the computer is an effective way to save time while examining composition and color choices.

H *Judy has recreated the antique store, stacking the desired elements behind the chairs.*

I *The completed painting takes you back in time.*

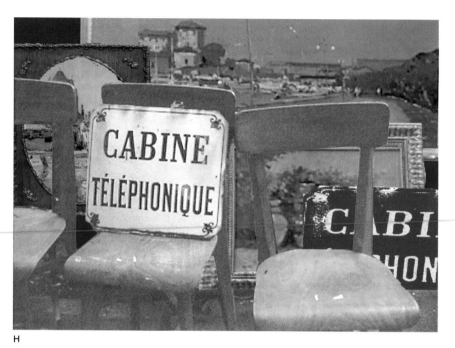

H

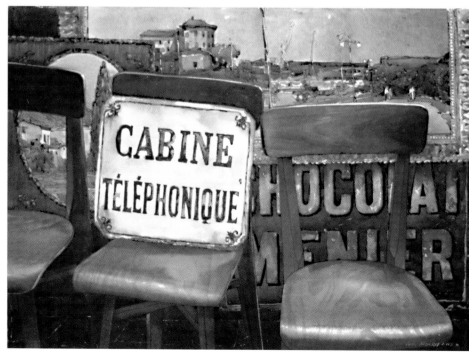

I

Defining Shapes and Value Patterns

"Dunes" by Jerry James Little
watermedia, 11" x 16" (28 x 40 cm)

When I first started painting, I was trying to paint every leaf on a tree. In my opinion, the hardest thing for a good artist to do is to eliminate what is not important and to develop what is. My goal for this painting was to develop a photo into an abstract work. I liked the horizontal interlocking shapes in Image A. My objective was not to paint the exact landscape, but to look for the value patterns of the shapes and colors while connecting them into an interesting design.

1. I started by working from the top by isolating a few shapes as they appeared in the photograph with the Lasso tool. I then put them on separate layers and filled the shapes with colors that I had selected from the Color Palette and then filled with the Paint Bucket. Separating the layers would allow me to move the shapes around as I worked. (Image B)

A *This landscape photo shows well-defined shapes and values.*

B *Layers and colors are established.*

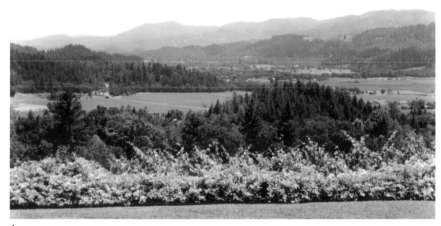

A

B

2. As I was not yet sure of the shapes and colors I wanted, I decided to do a test sketch to help determine my direction (Image C). I experimented with some warm colors and layers, and added a dark sky and sun. The sky was put in by highlighting that area with the Magic Wand, and adding the color with the Paint Bucket tool. The moon was drawn with the Lasso tool and color was applied with the Paint Bucket tool. There are always several ways to do a function in Photoshop. This test sketch, however, did not work for me as I felt the colors seemed too bright and gaudy. I wanted to go more toward softer earth tones.

3. The Layers Palette in Image D shows only the initial steps. They were constantly altered as I worked. This is what is so great about layers. You can change them in size and color and move each one around or put one in front of the other without disturbing the master artwork.

4. In Image E, I continued to play with shapes and colors. I added and changed various "test" layers. I also changed the sky color to pink, as I could see the darker earth colors suggested an evening setting.

5. In the final computer image F, I decided to make the sky less prominent and create more depth by adding the distant purple mountain range, which I drew in with the Pencil tool. Once it was drawn, I highlighted the mountain range with the Lasso tool and used the Airbrush tool to apply the color. The yellow sun was done in a similar fashion. Darker pinks from the sky were added to connect the foreground areas with the sky color to add excitement.

In my painting (Image G), I altered the shapes slightly from my computer sketch, but the format was there for me. The actual painting process went rapidly, as I had already solved the majority of the problems.

C *A test sketch experimenting with different colors.*

D *Layers can be helpful to organize design and color.*

E *Earth colors seem to predominate with a pink sky.*

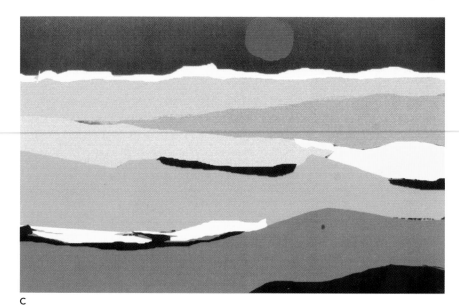

C

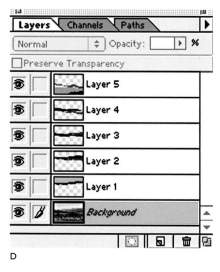

D

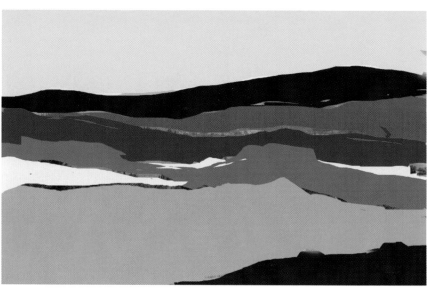

E

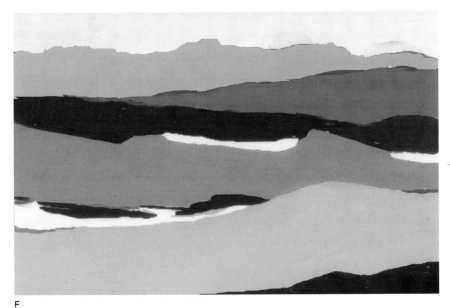

F

F *Adding distant mountains created more depth.*

G *The final painting shows few changes because the computer sketch solved most of the design problems.*

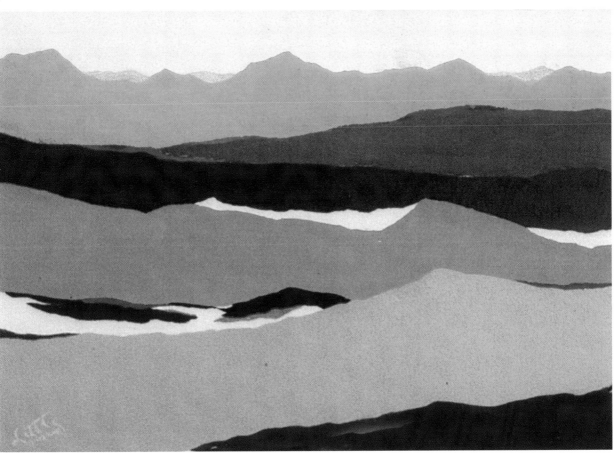

G

Creating Movement through Color

"Jack London Vineyard" by Manette Fairmont
watermedia, 24" x 24" (61 x 61 cm)

Manette Fairmont likes to paint "conceptual landscapes," an approach that lies between realism and abstraction. She carries her sketchpad everywhere to record important shapes and values with graphite or colored pencils, which she might supplement with photos.

Fairmont photographed this scene of the beautiful vineyards surrounded by rolling hills in the Napa Valley (Image A). She noticed a variety of values and shapes that would help make this painting a success. She enjoys selecting and abstracting these shapes and then placing and scaling them into new surroundings.

1. First, she zoomed in and cropped the original photo into a square format for closer detail of the vineyard. (Image B)

2. Fairmont studied the shapes and then began to abstract them by breaking them up into simple, flat shapes. For instance, she selected the shape of the oak tree and placed it onto a separate layer. Then she experimented with the value, saturation, and color of this single shape. (Image C)

3. She broke down other areas into strong shapes and began to build her design. As with the oak tree, each of these shapes was placed

A *The existing values and contrast in this Napa Valley scene needed to be enhanced.*

B *The photo was cropped into a square format to isolate important details.*

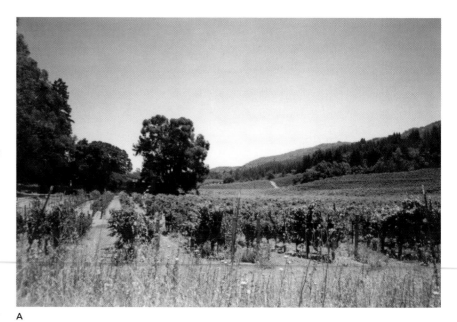

A

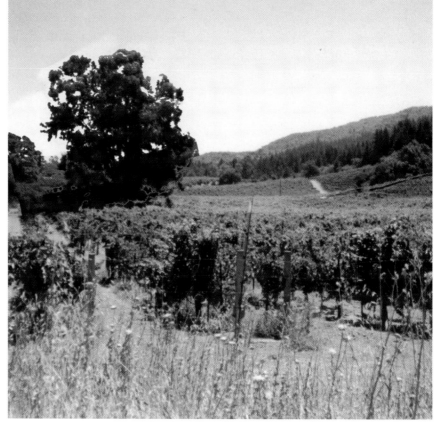

B

onto a separate layer. This allowed her to experiment separately with the value, saturation, and color of each shape. (Image D)

4. On the bottom right of the design, she cloned one of the vines, placed them in a row, and applied a red color. Each vine was scaled slightly smaller to give the feeling of perspective in a contemporary manner. The foreground textures were added to create a foreground space. (Image E)

5. In the end, Fairmont had sixteen separate layers. She moved elements around, rotated them, and played with their color and size. In the Transform command, you can scale, rotate, skew, distort, or change perspective. (Image F)

C

D

C *The dominant shape of the oak tree was the first that Manette Fairmont chose for her design.*

D *Other shapes were identified and placed into separate layers, where Fairmont could freely manipulate them for the creation of her design.*

E *The three red vines were cloned and moved into a row.*

F *In total, there were sixteen separate layers involved in pulling the design together.*

E

F

6. Fairmont chose to fill the spaces in between the shapes with black to make them recede. (Image G)

Fairmont enjoys playing with color and shapes in an abstract/realistic manner. The computer allowed her to move the shapes and colors around until she arrived at a combination that pleased her. It also influenced the end product with vibrant color relationships she would not have normally used. (Image H)

G *The final computer sketch was unified with three strong black shapes.*

H *Manette Fairmont's vibrant, dynamic painting has been changed considerably from the original photo, but the shapes can still be found.*

G

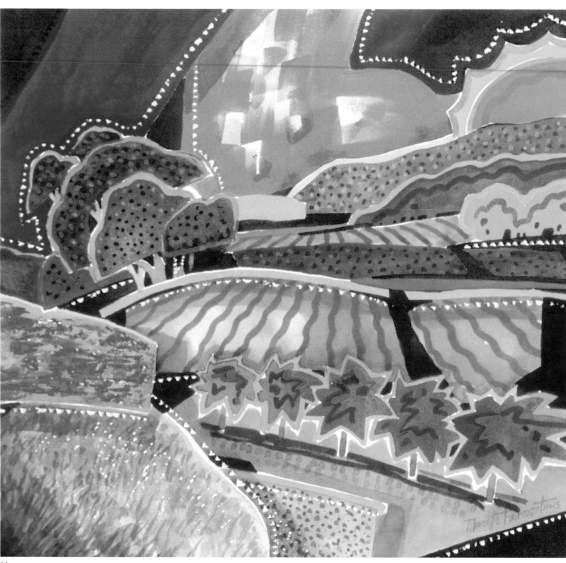

H

Abstracting with Color

"San Diego Fantasy" by Frank Federico
watermedia, 22" x 30" (56 x 76 cm)

Frank Federico works in all media. His tastes and curiosity are very diverse. Nature inspires him in all its form, but nature also encompasses people. Hence, he has much to select from, and to be a catalyst for. Frank says that his work is very eclectic, borrowing from many different sources. He manipulates and renders the picture plane with edges, gradations, and planes, as well as foreground, middle ground, and background.

Frank will sometimes make a sketch or a color schematic, if a foundation is required. Other times, he will liberate himself by painting freely. "Painting is a celebration!" he says. Frank works in watercolor, acrylic, gouache, pastel, and oil.

The thought behind this painting was initially to illustrate the panorama of the view and the mood that Federico was in. The execution of it would add excitement by shifting and altering the subject matter in an innovative way.

1. First, Frank studied three photos (Images A, B, and C) that he had taken on a trip to San Diego, California. Then, he did a quick sketch (Image D) to give us an idea of which direction he was headed. Using Image B as a base, we determined that the proportions of his sketch were longer than the photo, so we added some width to Image B to retain those same proportions. (Image E)

2. Frank liked the eucalyptus tree in Image A, so we highlighted just the tree, copied and pasted it into Image B, automatically placing it onto a separate layer. It was necessary to scale it with the Scale command and place it almost directly on top of the palm tree in Image B. Returning to the background layer, we eradicated the remaining part of the palm tree that was still visible by cloning some of the background water and landscape over it. (Image F)

Next, the cityscape was copied and scaled to approximately the same scale as in his sketch in Image D. The bridge and bay were copied from Image C and brought into the base file. On its separate

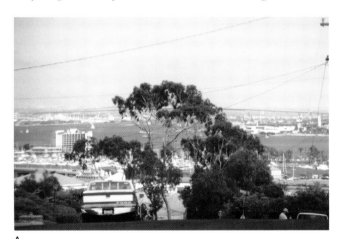

A

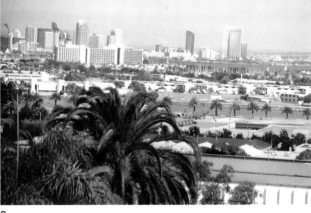

B

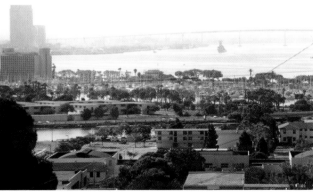

C

A *A harbor photo scene of San Diego, California.*

B *Another San Diego landscape showing the city in the distance.*

C *Another photo of the San Diego Harbor.*

D *Frank's quick sketch to help determine some of the compositional ideas he had in his mind.*

E *Comparing Frank's sketch (Image D) with Image E, note how we must add more of the bay to the scene. The entire scene is evenly busy and offers little place for the eye to rest.*

F *The addition of a larger bay shape gives the viewer a calm shape compared with the texture and detail of the rest of the composition.*

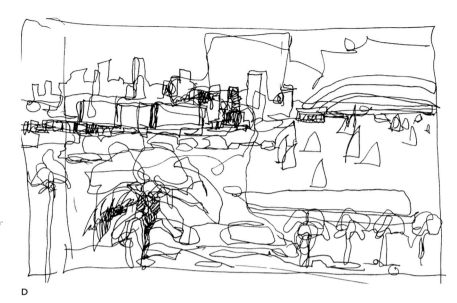

D

E

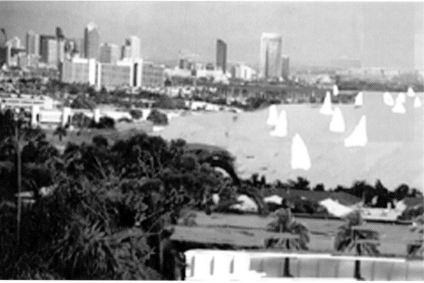

F

layer, we altered the values and colors to be similar to the lighting in Image B so they would look correct when merged together. The empty sky area was cloned over with some of the blue sky color. We copied one of the small palm trees in Image B and pasted it onto a separate layer. Then, it was duplicated three more times and the duplicates were placed in a line in the right foreground space.

Because the bay was way off in the distance and hardly showed,

Frank wanted more water to show. In the final image you see how that large shape worked to direct your eye into the painting and give it a place to rest. A large part of the land shape on the right was cloned over with a bluish color to represent the water. The bay, of course, needed some sailboats, so we roughly drew in some white shapes to represent them with the Paintbrush tool, loaded with white. For these purposes, the artist does not need to render these shapes

exactly. It is only for preliminary conceptual design and composition.

3. Once all of the shapes were in place, the file was flattened in the Layers Palette and Frank started playing with the values and colors to take the image closer to his style of painting. In the Hue/Saturation command, we just played with the sliders of hue, saturation, and lightness until we arrived at a color scheme that he liked. He could completely alter the colors, taking them out of realism and into more of a "fantasy" effect. In using the computer to do this, he could test and retest many combinations until he arrived at one that pleased him. (Image G)

The artist felt the computer printout created an interesting and cohesive structure to work from and he stayed within the composition in his final painting. (Image H)

Frank feels this computer experience gave him an extra dimension to refine a composition, but the artist would still shift, alter, and recompose "after the fact, as this is the inquisitive nature" of what artists do. Frank would use the computer as a tool, but not as an end in itself.

G

G *The colors and values have been completely transformed into a fantasy scene.*

H *Frank saturated the colors even more in a painterly fashion. Note how the small palm trees are important elements to bring the viewer into the landscape.*

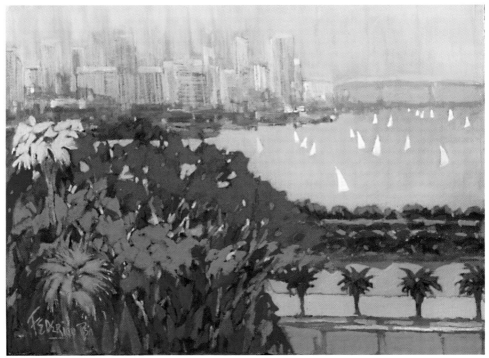

H

Creating Depth

"San Gimignano" by Gerald Brommer
acrylic, 36" x 60" (91 x 152 cm)

Several things get Jerry Brommer's creative juices flowing, such as interesting clusters of structures, exceptional light conditions, wonderful textured surfaces, faded colors, and a sense of place.

Jerry likes to paint directly with little or no planning. Initially, he has no conclusive concept as to how the finished painting will look, but he does know how he wants it to feel. Jerry will draw in a few large shapes on the support and begin laying down color. He will use many glazes to build up the work from generalizations to specifics, designing along the way. At some point in this process, he will start responding to the developing painting and disregard the original source material. The painting will develop a life of its own.

Jerry brought several photos and some sketches he had taken in Tuscany, Italy, to the session. He said the medieval structures of San Gimignano were always fascinating to him and he wanted to combine these fine old buildings with some flowers and a balcony to make up

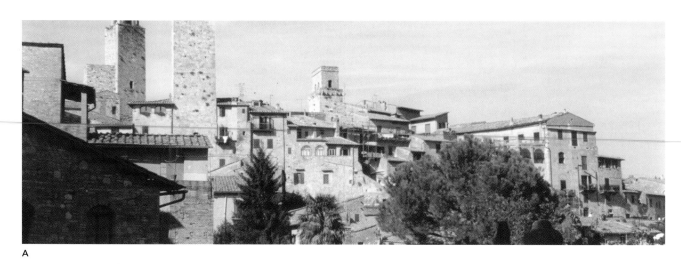

A

A *A panoramic photo of the medieval village of San Gimignano.*

B *A photo of a wall filled with flower pots that would be used in Jerry's composition.*

B

a combined image that might be best described as a place he would like to spend a great deal of time.

1. To begin, the right side of Image A was cropped to create an approximate ratio of the painting size he was planning (3' x 5'). He felt the sky was uninteresting so we highlighted it and added more magenta (Color Balance command) and saturation (Hue/Saturation command) to warm it up a little. Jerry felt he might like to see the tree on the far right turned to a rusty red color. (Image D) In doing so, he felt the sky was now too intense so we desaturated it a little by highlighting it and bringing down the intensity in the Hue/Saturation command.

2. Adding some flowers and a wall to the foreground would create a deeper sense of dimension. The flowers and wall were copied from Image B and pasted onto a new layer in the main file. The flowers were transformed with the Scale command and the wall was corrected in perspective. The wall was selected and with the Perspective command, adjustments were made to make it match the perspective of the scene. Some prior knowledge of perspective is required to use this tool effectively, just as you must know a little perspective to make your drawings look correct. Additional flowers were cloned into the area from Image B and some additional light flowers were added to the center flowerpots by cloning them from Image B. (Image E)

It is a bit tricky to clone from one image into another image. You must set your cloning point in the first photo. Then, you return to your master file and hold and drag the mouse over the area you wish to clone. Each time you want to reset

C

C *This photo brings the viewer closer to the village.*

D *Note the tree on the right is now a rust color and the sky has been enhanced.*

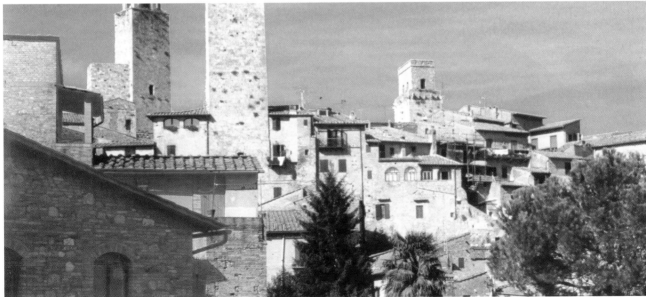

D

the clone point, you must return to your first photo, set the clone point and then return to your master file.

3. After placing the flowers and wall, there was some white space on the right, between the buildings and wall. We cloned some of the buildings and the palm tree from Image C to roughly fill in that white space. In the final image, Jerry thought the rust-colored tree we had changed was not adding much, so we changed it back to its original green. (Image E)

Jerry felt the process of using the computer to see possible combinations, arrangements, and color choices with this subject was fascinating. He was reminded of the story about the nineteenth-century French painter Gustave Courbet, who, when seeing what the newly invented camera could do, said, "The camera will become my sketchbook." In his painting, Jerry made further adjustments to the sky and the overall design, but pretty much followed the computer printout. (Image F)

E *The addition of the wall and the flowers gave the scene a foreground and added dimension.*

F *In the final painting, the sky was painted with even more drama, which helped to play up the village.*

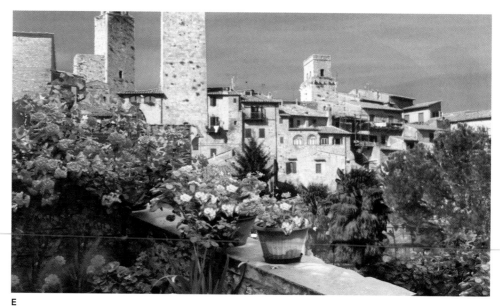

E

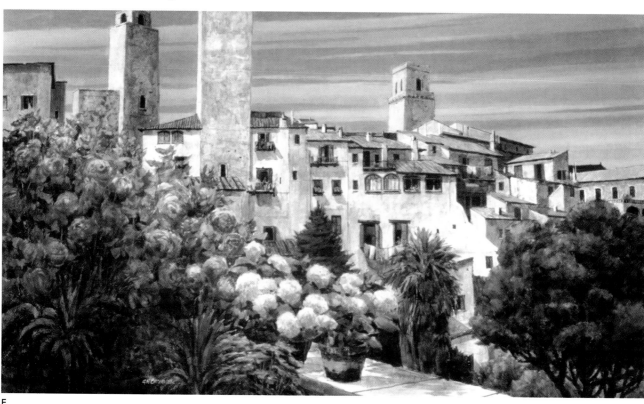

F

Developing Studies for Collage

"Memories" by Jerry James Little
mixed watermedia, 22" x 15" (56 x 38 cm)

I have done a number of paintings that deal with collage and texture and find it very stimulating to look for new ways to compose a foundation for any subject matter. Collage is a great way to use magazines and newspapers to form an interesting and different kind of image. This is a collage that was done with many scanned images, using several pieces of newspaper, an old photograph, and torn music from a book. The paper size was 22" x 15", making the proportion of width to length 1.47.

1. Starting with a blank computer canvas 4" wide by 5.88" high, retaining the 1.47 proportions, I filled it with a light raw sienna color background, as I wanted to establish the mood (Image L). I then tore several pieces of an old newspaper and put them in the scanner starting with images A, B, and C. I roughly scaled each of them to match my proportion of the computer file. Once I established the formula, it was easy to quickly scale the images. Each of these images was pasted onto separate layers in the main file and they were moved around until I was satisfied. I could continue to move these images as necessary because I hadn't glued them down as I might have done if I were working directly on the paper.

A

B

D

C

A–D *Torn collage pieces collected through the years.*

E

SAN FRANCISC

BRIDGE CELEBRATIO
WILL MAKE HISTOR
NOVEMBER 12-13-

F

H

I

G

E–K *More collage pieces.*

LE GANT
OF YOUTHLASTIC

BY REDFERN

© 1936
W B Co.

J

THE CLOSE
point where
so many plac
had seemed
shape as a w
up, the mole
shore v

K

2. In Image M, more collage material was added from the torn pieces of paper (Images E–K). The collage pieces were scaled in proportion to the file dimensions. I continued to adjust their locations. For the background spaces, I wanted to stay with light earth colors to keep the collage materials as the dominant points of interest. In most of my paintings, I work from light to dark.

L *A background color has been chosen and the scanned images of the torn pieces of paper are placed on separate layers.*

M *More collage material has been added on individual layers. At this point, the design was beginning to be established.*

L

M

3. In Image N, I wanted to connect the old newspaper collage pieces into the background and soften the hard edges. I did this using the Airbrush and Paintbrush tools with various colors and pressures. To add texture that would give an antique look, I applied the Noise and Sponge filters. In the lower area of the painting, I added a value change and a subtle cool blue color to create more interest and excitement in an otherwise drab area.

4. In the final painting (Image O), I continued to add texture and made some value changes.

I feel that artists should at least examine the many possibilities provided by the computer. It is a great way to build a collage. I can move pieces around with just the click of the mouse until I am satisfied with the design. In addition, I can actually see what added textures, colors, and values will do to my design without ruining the collage pieces. I never realized I could do a collage so effectively on a computer and also save time and effort. It's the first time I have ever done a painting without getting paint all over me. I printed the information for future reference.

Remember, using it in this way is not what we think of as computer art. It is a way to create more visual ideas in your mind as you work.

N

N *Texture and glazes of color were applied to connect the background with the collage pieces.*

O *The painting was completed with ease because I had already worked out most of the compositional problems on the computer.*

O

Creating a Sense of Space

"Cow in Time Zone" by Edwin Wordell
collage and watermedia, 22" x 30" (56 x 76 cm)

Ed Wordell works in a mixture of styles. Most of his representational work is executed on location. He likes to see how the light and times of day affect water reflections, shadows, and overall mood and then see if he can incorporate those feelings into his paintings. Ed starts fifty percent of his representational work with thumbnail sketches. Other times, he will go directly to drawing in shapes, followed with large washes and then, to detail work.

His studio abstract works, including collage, involve exploring ways to break up space, the effects of hard-edge color relationships, the introduction of depth to the picture plane and introducing, at times, a seemingly unrelated image.

Ed loves to work in most media. He arrived at the studio with a bag full of various watercolor and rice papers on which he had painted. He started by saying he wasn't sure where he was headed, but this was the way he normally worked. He did think he would do this painting on a full sheet of watercolor paper, 22" x 30".

A

B

C

D

A–D *Scraps of painted watercolor and rice papers.*

1. The computer canvas size was set up with the same proportion of width to length of 1.36, making a 6" wide by 4.41" high computer file. Each piece of paper was scanned and placed in the file (Images A through G). As these pieces of paper were to be in the final painting, each piece of paper had to be scaled down by approximately one-fifth to retain the same relationship of the watercolor paper to the computer file. This was only a sketch, so he could roughly scale these pieces of paper. (Image H)

An especially intriguing shape and texture was the cow shape that he had cut from one of the papers (Image E). The texture had been achieved by applying melted wax (to save the light shapes), much like batik. Acrylic color was applied and when dry, the wax was ironed off using newsprint to soak up the wax. This cow stencil was then cut out. This gem was created from a painting that had not worked!

2. The pieces were then randomly placed on the computer canvas on separate layers in the file. Each time you paste an image into your file, a new layer is automatically made (Image I). Once all of the pieces were in the file, the collage pieces in the computer were moved and rotated independently until he arrived at a placement that pleased him. At this stage in his actual painting, he would glue the scraps to his paper.

3. Then with the Polygonal Lasso tool, he began to define large flat divisions of space. Since he did not yet know what color he wanted them, we painted each a different gray value so he could visually see the space divisions as he was working. (Image J)

E *A cow shape was cut from a piece of paper that looked like a batik.*

F, G *Two more watercolor scraps.*

H

H *The scraps of paper, which have been proportionately scaled, are randomly placed in the computer file.*

I *The pieces of paper are arranged on the computer canvas.*

J *Ed started creating depth to his painting by placing grayscale polygonal, overlapping shapes behind the scraps of paper. He would determine the color scheme later.*

I

J

Creating a Sense of Space **65**

4. Once all of the gray shapes were in, Ed selected an analogous color scheme for them. Because each shape was on a separate layer, it was easy to highlight the shape and paint it a color with the Paint Bucket tool. To create more depth to the space, he decided to add shadow shapes to these large shapes. We used the Polygonal Lasso tool to draw them. Each of these shadow shapes had been placed on a separate layer also, so we could color them the appropriate shadow color and also manipulate the front to back placement, by changing the stacking of the layers in the Layers Palette. (Image K)

In Ed's case, it took a little longer to scale the collage pieces proportional with the final image than he could have done directly on the paper. He felt it was also somewhat time-consuming, drawing the lines of shapes introduced into the composition. He did feel that once the lines were drawn on the computer, it was much easier to rearrange, enlarge, and diminish them. He did the painting with few changes from his normal process (Image L). From this session Ed felt that he would consider using the computer for additional design elements in the composition and exploring various colors and value relationships.

K

K *Several polygonal shapes were given color and shadows to create even more depth.*

L *Wordell's painting was very close to the sketch because, for the most part, the scraps of paper were part of the actual painting and the computer sketch.*

L

Changing a Single Perspective

"Domes of St. John, Palermo, Sicily" by Patricia Allen
watermedia, 21" x 29" (53 x 73 cm)

Patricia Allen works with several different pigments at one time. She strives for a stylized response to landscapes, including unusual perspectives, patterns of interlocking shapes, and brilliant color. She also likes the interplay of positive and negative shapes.

Pat usually begins a painting in "plein air" with transparent watercolor. She will apply the pigment without the use of a sketch and focus on the details later, back in her studio. She uses watercolor, gouache, acrylics, inks, or casein to develop a painting. Photos are also used to further define her work if necessary.

In her travels, Pat had taken a photo (Image A) and had done a sketch (Image B) on site. She had intended to do this painting for a long time, but never felt quite confident to attempt it until she was able to test her "thoughts" on the computer. She wanted the painting to be about the domes. Her sketch showed a flat, frontal perspective, yet the photo showed the domes high above the vanishing point. In order to achieve what she wanted, we would have to isolate each dome and change the perspective and scale to match her sketch.

1. Starting with Image A as a base for the image, unwanted elements were deleted by cloning over the tall cypress tree on the right with some of the sky. (Image C)

2. As shown in the Layers Palette in Image D, each of the elements was copied from the base background layer and pasted onto a separate layer. Then each element was scaled, altered in perspective and/or distorted to match her sketch. Each of these commands in Photoshop is called Scale, Distort, or Perspective. Layer five (Image D) shows where we cloned in some additional foliage for the foreground shrubs. By altering them all on separate layers, we could manipulate the images, yet still "see through" all of the layers to determine their location and relationship with the other elements. In this manner, we divided the space of the canvas. Because Pat's photo showed such a low perspective point, the domes were hardly visible. By moving, scaling, and distorting them, she was able to build a story about the domes that was closer to her sketch concept.

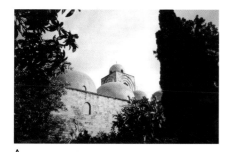

A

B

C

A *Pat wanted to paint these domes, but was unable to take the photograph from the correct angle.*

B *Pat's quick sketch of the domes on site.*

C *The domes are scaled, moved, distorted, and altered in perspective to make them appear more dominant in the picture plane.*

D *Layer's Palette showing all of the domes placed on separate layers so they can be moved and altered.*

D

3. Once the images were set, we "flattened" the file by combining all of the layers into one layer in the Layers Palette. The entire image was posterized to only five levels of value with the Posterize command. Posterizing helps you to simplify your shapes, saturates the color, and deletes unwanted detail. (Image E)

Adjusting the colors and intensity is easily done with the Hue/Saturation command. In Photoshop, you can also go to the Variations command to visually see what your image would look like with more red, green, cyan, yellow, blue, or magenta. In this window, there are small photos with each of these changes applied to your image. After that adjustment, we went to the Hue/Saturation window and again, altered the colors and values. To make the stone wall warmer, we isolated that shape by selecting it roughly with the Lasso tool and independently altered its color. Finally, we scaled the width slightly to maintain the original proportions of the design.

Pat felt she would save time using the computer. It gave her many new ideas regarding perspective, color, shapes, scale, and values. Without the use of the Perspective and Distort tools, the painting could not have developed as it did (Image F). As she painted, Pat made some changes from the computer image, but felt once she learned the software program, changes would be less necessary and was excited about the many possibilities for design and color variations in her artwork. In the future, she will take more risks while using the computer to develop her art.

E *Posterizing the image at the end brought the feeling of the domes more toward Pat's concept of the painting.*

F *Here is the final painting with a new perspective.*

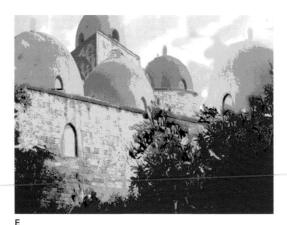

E

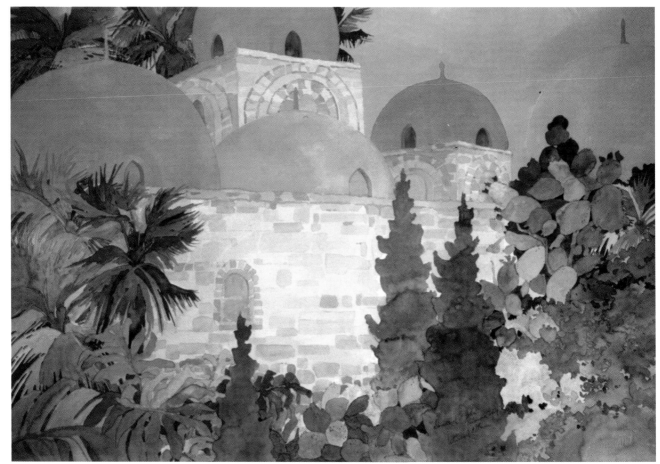

F

Arranging Floral Elements

"Daffodils II" by Julie Limberg
watercolor, 21" x 14.5" (53 x 37 cm)

Julie Limberg likes to paint realistically. She is particularly interested in how light affects objects, including reflected images, transmitted light, and shadows. She also loves to work with subtle color variations.

The artist usually starts her painting with some small thumbnail sketches while painting in "plein air." When she paints a still life, she will do several small sketches and draw it onto a full size, transparent paper, then outline it in ink and trace it onto regular watercolor paper.

Julie was excited to do this flower painting. For her, flowers are more than mere stems, leaves, and blossoms. They embody beauty and versatility. They present many stages of life and evoke a variety of moods and emotions. Julie brought three photos that she liked because of the way the light hit the flowers, but the prints were very cool in color and the compositions were not good. She decided to try and combine the various flower shapes into one image. Since she had taken the photos about the same time of day and in the same light, we could easily do this. When combining photos, you must be careful that the sunlight is coming from the same direction in all of them to make your new image believable.

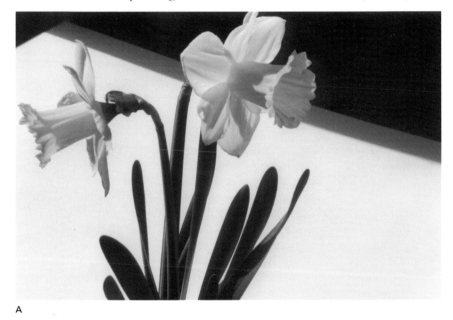

A

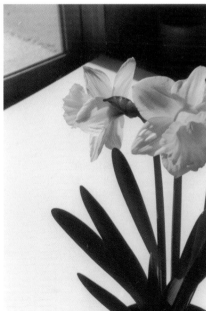

B

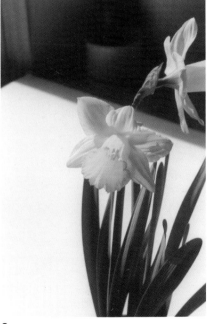

C

A *Original photo of the daffodils. Note the unrelated background.*

B *Another photo of daffodils with the wrong background.*

C *Julie took many photos of the daffodils with the same light source, knowing she would put the shapes together to create her painting.*

1. Julie thought she wanted to paint this on a half sheet of watercolor paper. (21" x 14.5" is a proportion of 1.44.) We set up the vertical format computer file to be 3.96" wide by 5.7" high. Using Image A as a base file, we first deleted the background of the daffodils that she did not want in the painting. To quickly select the background, use the Magic Wand tool to select the light background shape, then, while holding the Shift key, add to your selection by picking the large dark shapes. If you still don't select all of the pixels, still holding down the Shift key, add the missing pixels with the Lasso tool. Keep doing this until the entire background shape is selected, then hit the Delete key.

2. Then, we copied the left flower in Image B and pasted it into the main file, which automatically placed it on a separate layer so it could be manipulated, scaled, rotated, until she was satisfied with the placement. In Image D, we have also copied and pasted both of the flowers from Image C, but on separate layers so we could easily alter their placement in the new design. The small, square pattern indicates a transparent background. This is Photoshop's way of telling you the background is transparent versus white. Otherwise, they would both look the same on the monitor. Note at this point, the image is not set to the correct proportion as Julie was not sure where she wanted to crop, so we made the Canvas Size larger to give her room to manipulate. After placing the flower shapes, she was then able to crop the image to the proportions of half a watercolor sheet.

3. In the Layers Palette in Image E, you can see the many layers we were working with to create the new floral image. Some of the leaf shapes had to be painted in. The color was picked with the Color Picker, then a Paintbrush was

D

E

selected, and leaves were extended or filled in.

4. Once, she was happy with the placement of the flower shapes, we merged those layers together to reduce the file size. In the Layers Palette, select Merge Visible. The visible pertains to whether a layer is turned off or on. If the layer is turned off, it will not be merged with the others. You can merge three layers out of four together this way. Then turn the other layer back on and have just two layers. This is a good way to keep your file size smaller or to work with the colors and values all together instead of on separate layers. After the layers were merged together, we could "warm up" the colors at the same time to make them more inviting. (Image F)

5. At this point, Julie was unsure of what she wanted on the background, so we tested various colors and gradients on a separate layer so we could instantly revert back if she didn't care for it. See the bottom two layers in Image E. The

background (Layer 1) was fairly close to what she visualized, but it was still a little too intense for her, so we duplicated this layer (Background Wash layer) and started "glazing" a pale wash of cobalt blue over it at about ten percent opacity—much like you would do if you were painting a thin glaze of color. By doing it on a separate layer, we could keep reverting to the original "Layer 1" if needed, by simply turning the layers on or off. Also, the highlights on the leaves on the far right were selected with the Magic Wand and intensified to give them that final spark with the Brightness/Contrast command. (Image F)

Julie found that the computer allowed her to explore more possibilities with composition, color, and values, as well as save her time. She was able to see many design ideas that had not been in her mind before. While she still made changes in her final painting (Image G), she feels that working this way pushed her from the familiar comfort zone into the world of "What if?"

F

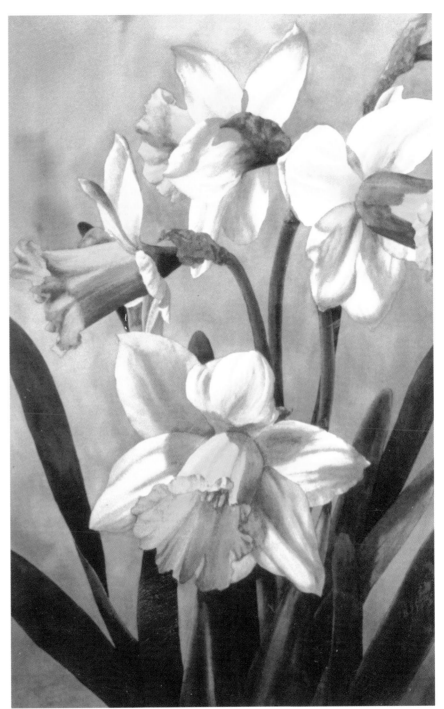

D *The individual flower shapes have been independently copied and placed on separate layers so they can be manipulated for the composition.*

E *The Layers Palette shows the many layers used to create the arrangement in the final design. The background wash was a Gradient fill of two colors.*

F *The purple background wash color was chosen because it is the opposite of yellow on the color wheel and would highlight the flowers more.*

G *Julie followed the computer sketch fairly closely, but cropped in slightly in her painting to bring the viewer in.*

G

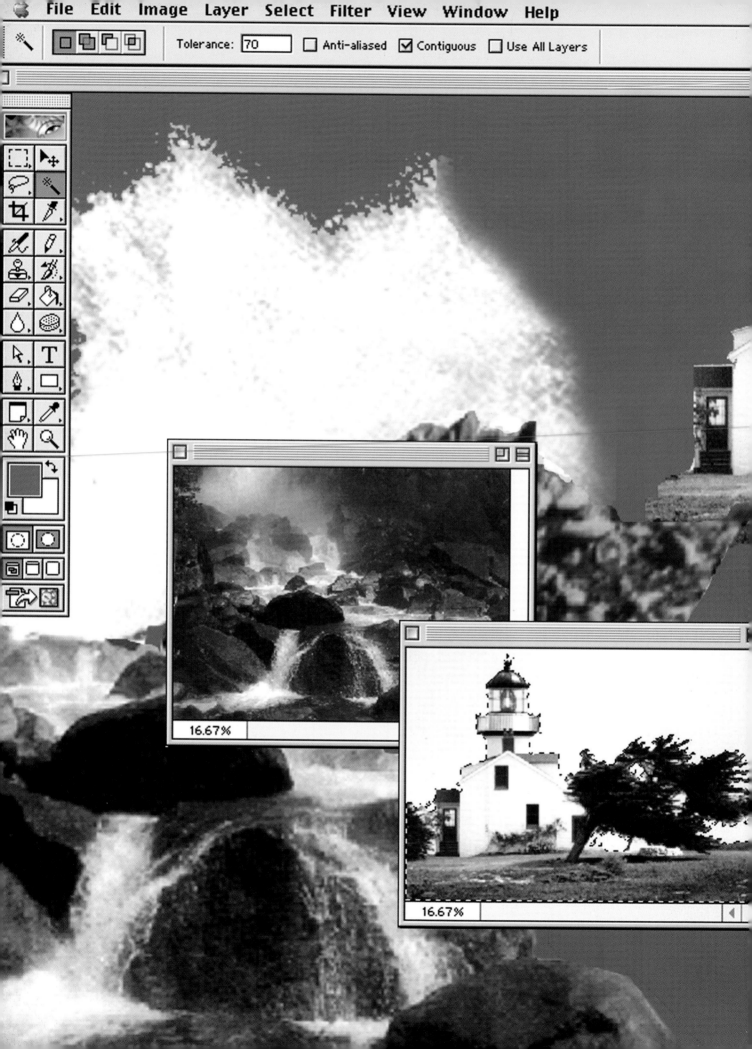

Combining Photos

Applying Textures

"Interlude" by Jerry James Little
watermedia, 13.5" x 10" (34 x 25 cm)

As I am basically an experimental-ist painter, I like to take realistic subject matter and see if I can create exciting changes or add drama to an existing image. I paint many different subjects and am not beholden to any one genre. I work in all media and many of my paintings have three or four different pigments in them. I have a special fondness for colored ink.

In this painting, I used acrylic and watercolor. A masking fluid was used to create texture in selected areas similar to the final computer image. I first spattered some masking fluid in a few areas, then applied a light glaze, rubbed off some of it, and applied another glaze. This process can continue for several applications, usually with a little darker value each time. As part of my music series, I worked with three photographs (Images A, B, C) and used Image A as my base picture.

I selected watercolor paper with an image size of 13.5" x 10" or a proportion of width to length of 1.3. I set up my computer file to be 5.22" high by 4" wide.

1. My first step was to copy and paste the guitar player (Image A) onto a separate layer in the master file. He was highlighted with the Marquee tool and flipped horizontally using the Flip Horizontal command so he would face the other direction. I wanted to place him on the right side of the painting and turn him around so the viewers' eyes lead back into the painting. Next, I adjusted the contrast slightly and added a brown tint to his clothes by highlighting the clothing and adjusting the colors in the Color Balance command. (Image D)

A

With the guitar player on a separate layer, I was able to start constructing a background. I painted several shades of brown using the Airbrush and Paintbrush tools and started to build up some texture. Turning the guitar man's layer back on, I moved him around until I was satisfied with his location. I used the Pencil tool to start drawing his legs and other background areas.

2. In Image E, I highlighted, copied, and pasted the base viola from Image C and the head of the musician from Image B. Both the head and the base viola were reduced in size using the Scale command. At this point, the hand of the viola player is still there but I can remove it at any point by cloning some surrounding wood texture of the viola over it.

3. I continued to draw in the guitarist's legs and other areas using the Paintbrush tool. I wanted to make the musician's head part of a sign board so when I was satisfied with his placement, I used the Clone tool to soften the hard edges in his neck so it looked like part of the sign. I also continued to adjust colors. (Image F)

Sienna and a cool blue were added to the base and a light blue glaze was added to the lower area to create a smoky cabaret effect. I decided to add type to add depth to the painting. With the Text tool, I typed the word in the font and size that I thought I wanted. I could scale, rotate and alter the color of the type to work with my design. The text can be moved in front of or behind an image by simply moving one layer over another layer in the Layers Palette.

B

C

A *A photo of a guitar player.*

B *Another photo of a guitar player.*

C *A photo of a bass viola player.*

D *The guitar player from Image A was placed on a separate layer and the background painted in.*

E *The head of the guitar player from Image B and the base viola from Image C were moved into the design.*

F *The musician's legs were drawn in and color was added. Text was added to the design to add interest and depth.*

D

E

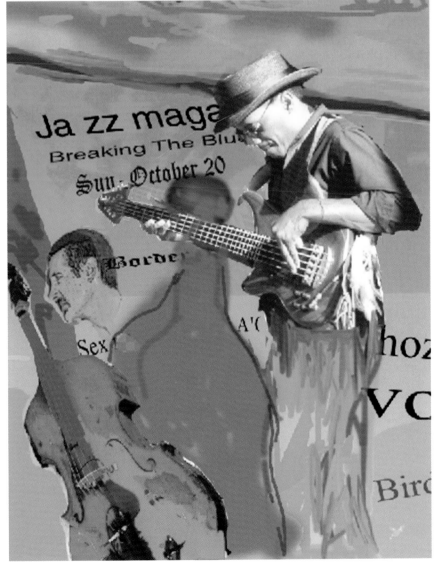

F

4. In the final Image G, additional adjustments were made to colors and a study of the values in grayscale was made. I also decided to add more texture to the work by using the filters available to me. In this case the Blur, Noise, and Sponge filters were used. I now felt I was ready to start the painting.

5. In the final painting (Image H), more texture and the feeling of smoke in a cabaret were added for a more painterly effect.

What I feel is so incredible about the computer is the visual information it offers in most all aspects of the creative process. As you can see, I have composed a painting using only the subject matter I wanted from each photo and consolidated them into one strong image. Further, I have produced the design I wanted and made the needed color adjustments, as well as adding texture ideas.

I was able to paint with complete confidence, as most all prob-

lems had been resolved. I made very few changes on the final painting. Sometimes you will not need to finalize your image as you may only want reference material from which to work. Another useful method is to use a digital camera and take a photograph of your painting, then put it in the computer and test out any modifications you might want to make. Then you can return to your painting and make the corrections with confidence.

G

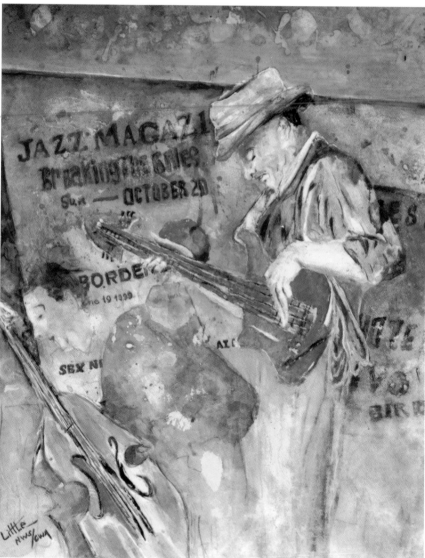

H

G *Filters were applied to give the effect of a cabaret.*

H *More texture and smoke were added for greater atmosphere in the final painting.*

Painting Portraits

"Nestled in Sunset" by Leroy Allen
watercolor, 29" x 21" (73 x 53 cm)

Leroy Allen's main interests are figure and portrait painting. His challenge is to bring out expressions of the human form, such as emotions, determination, attitudes, and beauty.

Usually, Allen begins his watercolor painting with a detailed, freehand drawing and then proceeds to do progressively refined sketches. Then he applies moderate to intense color washes. By placing a photo of the finished painting in the computer, he uses it to make changes to help him finalize a painting. He studies his work on screen to judge if the values are correct and makes test "fixes." The paintings usually take several days to finish.

For some time, Allen had wanted to paint a portrait of his daughter using this reference photo, but he wasn't happy with the colors in it (Image A). He was also concerned with the lack of detail on her face. However, the photo had some redeeming qualities, such as the effect of the light playing on her figure. Using the computer, he was able to recover much of the detail that had been blown out by the light.

Allen decided he wanted to paint this image on a full sheet of watercolor paper (a ratio of 1:1.38"). To maintain this ratio, he cropped a little off the right side of the photo, throwing her face a little more off center.

1. His daughter's clothing needed to be "dressed up" a little. He changed her pants and sweater to a blue/black color (Image B, which is an enlarged section). To do this, he selected just the blue denim pants and adjusted the color and values toward a darker blue/black. To make the selection of just her

pants, start by picking colors with the Magic Wand, hold the Shift key down, and add to the selection with the Lasso tool until they are entirely selected. Be sure to save the selection in the Save Selection

command. To change colors, go to the Color Balance dialog box, which allows you to adjust color levels by adjusting slider bars. Think of this as mixing colors on a palette.

A

A *In this original photo, the colors lacked contrast and there was a lack of detail on the subject's face.*

B *A close-up view of the figure to help see the detail on her face and clothing.*

B

Then, he selected the brown sweater and changed its color to a matching blue/black of the pants. To change the color from brown to blue/black, the amount of magenta was reduced in the Color Balance dialog box and the saturation was decreased in the Hue/Saturation dialog box. This dialog box also has slider bars to adjust. He saved the sweater and pants selections by choosing the Save Selection command in case he wanted to make further changes.

To increase the contrast slightly on her clothing and enhance the lit areas of her body, he zoomed in on that portion of Image B, went to the Load Selection dialog box, loaded both the sweater and pants selections at once, and made the adjustments in the Brightness/Con-trast command. You will find using the Zoom tool can help you come in close to your subject to see detail and colors. By increasing the contrast slightly, more detail of her face appeared. You must be careful to not go too far with this or you will blow out the light shapes or lose them entirely and not be able to get them back.

2. Next, Allen decided he wanted the background to be cooler and slightly darker, similar to the color in another photo he had taken (Image C). He copied a small square section of the wall, then pasted it into Image D. It was auto-matically placed onto a separate layer. He did this to see how the color of the wall in Image C would look in his composition. This is a good study of how the computer can help you to see color relation-ships. The wall in Image C appeared to be a light wall, but when the wall color in Image C was surrounded with a light color, it suddenly becomes much darker. (Image D)

C *This photo was used to copy the color of the wall.*

D *A color patch of the wall from Image C was pasted onto a separate layer so the entire wall shape could be adjusted to match.*

E *The viewer is now brought closer to the figure. Note how by changing the wall color, the light shapes on the figure become even more important.*

C

D

E

3. Returning to the main layer of the image, Allen selected the entire wall shape. He accomplished this by using the Magic Wand to select as much of it as possible. Then he held down the Shift key and kept picking more of the pixels. You can also use the command Grow, which tells the computer to pick up some nearby pixels. He started adjusting the Color Balance and Hue/Saturation, to match the copied patch. After the adjustment was finished, he deleted the layer with the patch on it, as it was no longer needed. Using the computer to match two areas of color makes you sensitive to color and value in new ways. (Image E)

Allen also wanted to lighten the shadow under the left pillow slightly. He made a rough selection of the shadow and lightened it by moving the slider in the Brightness/Contrast command.

4. He then viewed the entire image in the Grayscale mode to check his values and shapes (Image F). This allowed him to determine further changes in composition. He decided the wall area was too large, so he cropped a little off the top, bringing it in closer to the figure, as it appears in the final painting (Image G). The width was cropped accordingly to maintain the ratio of a full sheet of watercolor paper.

F

F *The image viewed in the Grayscale mode.*

G *Leroy was able to enhance the lighting even more in his painting.*

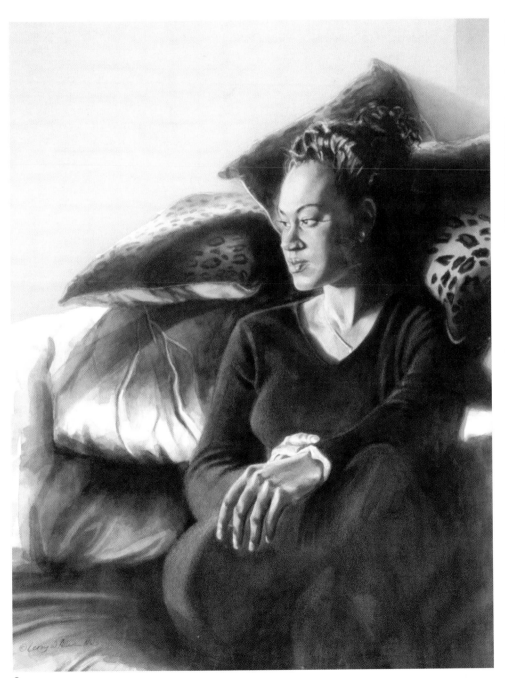

G

Choosing an Unusual Format

"Provence Patterns IV" by Claire Schroeven Verbiest
pastel, 5" x 17" (13 x 43 cm)

Claire Schroeven Verbiest's inspiration comes from looking at people, objects, and landscapes around her. The artist wants to transform these ordinary impressions into extraordinary images that will charm the eye with intense color, dramatic light, and strong design. Claire starts her artwork by making small, contour line drawings of a subject with a pencil. When she is pleased with the space divisions, distribution of values, and color in these quick studies, she moves to the actual painting. Claire works both in watercolor and pastels.

While traveling in Provence, Claire came across this yellow house in Image A. Even though it was a new house, she liked the general shape of it and the way the light

A

A *A photo of a new house in Provence.*

B *A photo taken for the warm color of the field.*

B

was hitting the building. She also took photos of various fields of lavender, cypress trees, and more—all to help jog her memory of impressions once back in her studio.

1. Claire determined from the start she would design her composition in a long and narrow format. In doing so, she would eliminate the uninteresting shapes of the foreground and sky. We created a new empty file in Photoshop with long, narrow proportions of 1:3 in Image C. Then we copied Image A and pasted it into the new, long file. The house and landscape needed to be scaled slightly larger to retain the area of the field she wanted. Image C shows the extension of the background area that will need to be filled in.

2. Then we cloned some of the trees in the background area and extended them to the left and right of the house filling in the blank spaces. She also wanted to bring out the sky to echo the hot sun. We changed the purple sky to blue by picking the blue color from the Color Palette and painted with the Paintbrush the rest of the sky shape to fill in the missing space. (Image C, upper left corner.)

Claire wanted to bring in the warmth of the field in Image B, so we copied the entire field shape and pasted it into the new file. The field shape had to be scaled to fit the shape by adjusting it with the Distort command. Distortion on the field won't matter at this point as we are just adding a feeling of the texture of the field. The color was adjusted to be brighter for the entire image in the Brightness/Contrast command. The light blue lines you see in Image D were some guidelines to help Claire determine where she wanted her center of interest (the yellow house).

C *An elongated file was created to receive the image of the house.*

D *The warm field from Image B was pasted into the file and the remaining areas were painted in. Note the color of the overall image has been intensified.*

C

D

Claire didn't like the projecting porch so we deleted it and filled it with a color that we cloned from an adjacent wall with the Clone tool. We then copied a window on the main house and pasted it onto the smaller wall. The window had to be scaled smaller to look correct in perspective. Whenever you paste an image in the file, a new layer is automatically created for you to manipulate what you just pasted first without disturbing what is underneath. Once it is set, you can merge the two layers together to keep the file size small and use less memory. The same was repeated for the other window.

3. A feeling of a field of lavender was added behind the house by painting a purple color (Image E). The detail at this point is not important. She can do that when she does the actual painting. On a new layer, we cloned some of the trees in the foreground and changed the hue to more of a burgundy color. Claire can vary the colors even more when she paints them, but this will give her the general feeling she is after.

With a Paintbrush and some varied green colors, we roughly painted an indication of a cypress tree and some other foliage for the foreground. To give the center of interest that final spark, a few more adjustments of color and intensity on the house were made by highlighting parts of it individually and adjusting the sliders in the Hue/Saturation command.

Claire was aware that the computer could be a powerful tool in her arsenal of art supplies, so when she was invited for a "hands-on" demonstration of this technology, she accepted without hesitation. She was pleased with how quickly she could arrive at a good composition. Although the colors in the computer study showed the correct value and hue, she felt they lacked depth and richness. She made adjustments as she painted the actual picture (Image F). The artist found that this new technology enabled her to come upon many new ideas using the same reference materials. Even more significant was the fact that a lot of frustration could be saved by simply evaluating the image on the screen and deciding whether or not she should move on to the painting stage at all.

E *In the final image, the colors were adjusted to draw the eye more towards the house.*

F *Pastels help to create a soft impressionistic mood in the painting.*

E

F

Closing in on a Subject

"Heat Wave" by Randall Sexton
oil on linen, 16" x 20" (40 x 51 cm)

A typical painting day for oil painter Randall Sexton becomes an adventure and an exploration of the light, color, and many moods readily available in nature. This process is a rewarding exchange with the real world.

Randy's subject matter covers still-life, landscape, and figurative themes. He works with oils in "alla prima"—a wet into wet approach on a small scale. Randy is basically a "plein-air" painter and will sometimes work on several panels at one time to keep himself open to new possibilities. The artist usually works with about twelve colors and frequently uses a quick-drying medium at the onset and adds slower-drying linseed oil towards the end.

About a month before the computer session, Randy had been inspired to paint small sketches of people on the beaches of Marin County near San Francisco. The problem he encountered was that the figures moved around too much or worse, they would leave the area while he was trying to paint them. Although Randy does not use a camera very often, he decided to go back to the beach and take photos of people and come to our computer session and see what the computer could do to help.

1. Using Image B as a base, we discussed the size of his finished painting. He decided it would be 18" x 24" or a width to length proportion of 1.33. Since our computer file was 3.673" high, we must crop the width to be 4.88". After showing him the approximate crop placement, he decided he wanted a little less water above the wave, so we had to crop the width a little more in order to retain the proportions. (Image C)

The woman in black slacks was moved closer to the sitting figure. To do this the figure was selected, copied, and pasted onto a new layer and moved to her new position. The figure that we had copied (on the background layer) was cloned over with surrounding sand and water. She disappeared like

magic. The two dogs and the young girl with a tennis racket in Image A were copied and pasted into the base file, placing each on separate layers so they could be moved independently. (Image C)

2. After the young girl and dogs were placed in position, they were

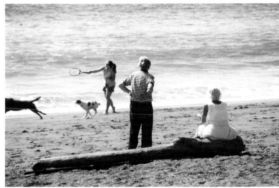

A

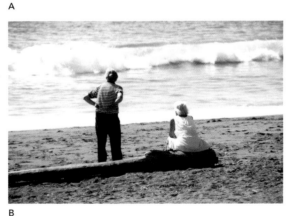

B

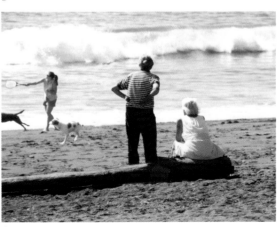

C

A *A photo of some figures on a San Francisco beach during a heat wave.*

B *A similar photo to Image A, but without the girl and dogs.*

C *The image was cropped to bring the viewer closer. The girl and dogs were added and scaled down slightly to set them further apart from the main figures.*

selected, lightened slightly in the Brightness/Contrast command, and blurred for less attention with the Blur filter. Knowing that we were going to brighten the colors, the file was flattened and we started playing with colors to make the image approach Randall's style of painting. You should flatten or merge all layers together to make future adjustments work on the entire image at once. If you do not, the adjustments must be made on each separate layer. The saturation was increased, color balance altered in the reds only, and it was posterized to fifteen levels of color. The shadow mid-tones were lightened slightly for more detail in the Levels command. (Image D)

3. As we were printing the final image for Randall, he asked if we could also blow up a certain part of the image (Image E). He realized that he could develop an entire painting from just an enlargement with this system. In the end, the painting that he produced for us (Image F) was of that enlarged portion of the image.

Randy felt that the final painting was directly inspired by the composition resolved in the computer session. While the composition remained a constant, the color and looseness of the paint handling became the area of "discovery" during the painting process. The artist feels the project did open doors for him in terms of pictorial possibilities. This experience created a working solution to the problems of figurative elements in a painting and has inspired him to finally purchase his first computer.

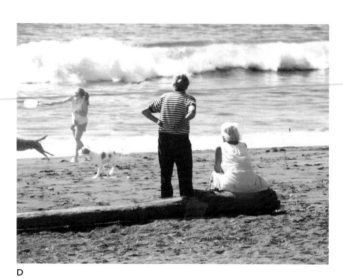

D

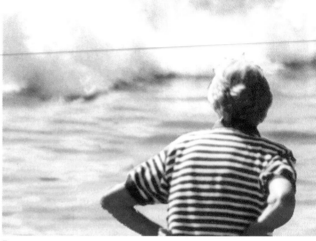

E

D *The color balance was altered in the reds to warm up the image.*

E *An enlarged view of the woman and waves inspired Randall to paint it instead of the other image.*

F *Randall's style of painting is to push the colors beyond reality in an impressionistic manner.*

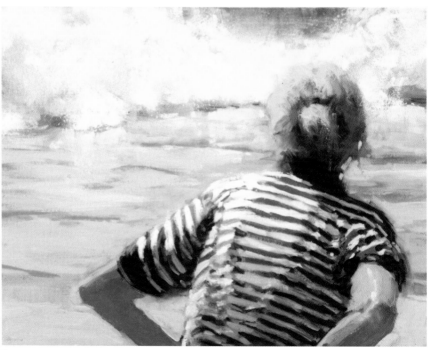

F

Replacing the Background

"Hook, Line, and Sinker" by Anne Fallin
watercolor, 16" x 22" (40 x 56 cm)

For Anne Fallin, the challenge is in finding her subject matter. She likes to paint objects that are universally recognizable, but atypical as subjects of a painting. With still life, such as animal crackers, toilet paper, and clothespins she can create dynamic and abstract patterns.

As she gets ready to paint, Fallin lays out many photos of the subject, in search of a compelling design. The preparation can be a time-consuming process. Often, she cuts out elements and tapes them together, then uses markers in ten shades of gray to do a preliminary design and value study. She then will apply a resist, like frisket, to the lightest values and paint directly onto the paper.

Fallin's father owned a hunting and fishing store. When she was growing up, she always liked the spectacular array of colors and shapes of the fishing plugs. Using photos of her favorite fishing gear, she wanted to create a still-life arrangement to paint (Images A and B).

1. Fallin wanted to set the arrangement against a background of rocks instead of newspaper (Image C). She adjusted the proportions of the computer sketch to those of the 16" x 22" watercolor paper (a ratio of 1:1.38). Since the background image was of rocks, it didn't need to be scaled in proportion. Instead, using the Distort tool, she highlighted the image and made it taller to fit the new proportions. This became the main file.

2. She selected the entire background newspaper in Image B and deleted it. In a complicated selection like this, there are various ways to select the background.

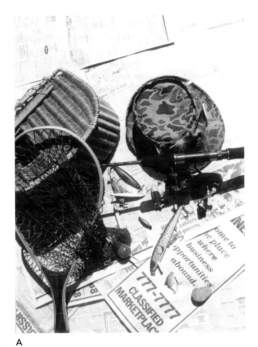

A

A A photo of some fishing gear.

B Another photo of some fishing gear laid on newspapers.

C A photo of some rocks that would serve as the background for the fishing gear.

B

C

D

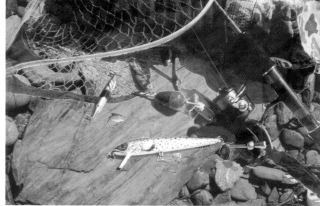

E

D *The fishing gear with the background removed.*

E *The background layer of rocks has been combined with the fishing gear.*

F *A few more lures were added to the final painting.*

F

By holding down the Shift key while selecting with the Magic Wand tool, Lasso tool, Magnetic Lasso tool, or Grow command, you can select the entire background. This works better than attempting to use just the Lasso tool to draw around the image. (Image D)

3. Next, Fallin copied and pasted the fishing gear (that remained after deleting the background) onto a new layer in the main file. In that layer, she enlarged the speckled fishing lure by selecting it and using the Scale command. There were still remnants of the original newspaper background, so she used the Paintbrush tool and color from the shadow area to paint over them. (Image E)

To better see the rocks covered in shadow, Fallin selected all the shadow areas, and in the Layers Palette, reduced the opacity so you could see more of the rocks in the layer beneath. For a final touch, the small blue and red lure in Image A was cloned and pasted into the main file. It was scaled, rotated, and moved around until Fallin found a spot she liked for it.

In her painting (Image F), Fallin made almost no adjustments to the final composition, except to add one army-colored plug she had remembered from childhood, and a sinker to give credence to the title *Hook, Line, and Sinker.*

Balancing Space and Form

"Cutting" by Melanie Lacki
watercolor, 21" x 29" (53 x 73 cm)

Melanie Lacki paints for a very simple reason: it makes her feel good. Light and movement are key factors in her attraction to a specific subject. Particularly known for her sense of color, Melanie is a contemporary realist painter who paints in a nontraditional style. She normally starts a painting by making at least two or three rough pencil sketches, followed by a small watercolor in her sketchbook. Her next step is to develop the atmosphere of the painting by glazing the paper in three or four washes before starting the painting.

For our session, Melanie brought some photographs of her daughter riding her horse. She had wanted to do a painting of her for a long time, but found it difficult to capture the exact scene she had envisioned in her mind because of the constant movement. In these two photos (Images A and B), she liked the figure in Image B and the basic background and calf in Image A.

1. To bring the figure in Image B to Image A, we first highlighted the figure and horse. A fairly accurate highlight was needed, so we drew around the shape roughly and then, while holding down the Shift key, used the Zoom tool to see it closer in order to highlight the extra pixels around the horse's tail and the girl's pony tail. While still highlighted, we added the shadow under the horse and copied and pasted it into our base Image A, which automatically created a new layer. This complex selection was saved in case we needed it again. The colors and values of the two photos were slightly different, so we adjusted the Color Balance on our new layer so it matched and blended with the layer underneath. (Image C)

A

B

A *A photo of Lacki's daughter cutting a calf.*

B *A similar photo of her daughter a few seconds later.*

2. In Image B, the photograph was shot closer to the subject than in Image A, so we had to scale the girl and horse and place them in the approximate position that Melanie wanted. (Image C shows both of the layers.) The background figure and horse in Image A would have to be deleted behind the new figure now. Returning to the background layer, we cloned some of the fence across the background figure and some of the green grass between the fence horizontals. When you need to color in between a busy image, such as the fence posts and rail, select the fence and rails quickly with the Magic Wand tool, then inverse the selection with the Inverse command and paint the selected area easily with the Clone tool without being concerned with painting over the fence. (Image D)

3. After discussion, Melanie was not quite sure where she wanted to crop this image, yet she wanted to use a full sheet of watercolor paper (29" x 21" or a proportion of width to height of 1.38). She said she wanted to crop some of the foreground, so we used the Rectangle Marquee tool and created a rectangle that was the approximate height of where she thought she

C

D

C *The figure from Image B has been placed on top of Image A.*

D *The background has been simplified and a tryout mat applied as a possible crop line to bring the viewer closer to the subject.*

E *The background trees have been lightened from Image D to create a greater sense of depth.*

F *The busy background has been simplified to direct the viewer to the rider and calf.*

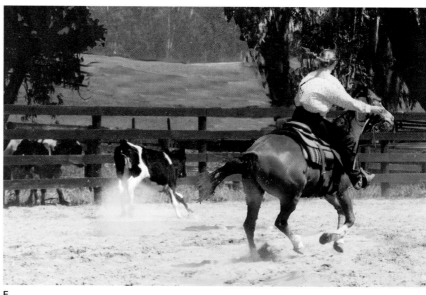

E

wanted to crop, but she still wasn't sure. The highlighted Rectangle Picture box was drawn the length as per the 1.38 proportion. The Show Info Palette tells you exactly how long you have drawn a shape. Then while this was still selected, on a new layer, we inverted the selection, creating a temporary frame that we filled with white to give Melanie an instant "mat" of what it would be like if she cropped it at that point. By framing this image on a separate layer, we could instantly view it with without the crop by turning the Eye icon on or off in the Layers Palette, which indicates the layer visibility. Once she was happy with its placement, we cropped the computer image and deleted our temporary mat layer. (Image D)

4. To create a deeper sense of space, we highlighted the background tree shape in the distance, lightened it, and brought the contrast down slightly. Lastly, we highlighted the calf and brought up the contrast slightly to "pop" it more to the front. (Image E)

Not certain if she wanted to retain the diagonal fence on the field, Melanie asked to see the background field without the diagonal fence on it. So on a separate layer, we cloned grass over the fence for her to see if she liked it with or without the fence. By doing it on a separate layer, we could view it either way instantly by turning the layer on or off. The decision was made to omit it in order to keep her design simpler.

In the final painting (Image F) the values were pushed a little further.

Melanie had already been researching the use of the computer as an editing tool for her photographs and drawings. It was a procedure that she found exciting, but she didn't have the knowledge or equipment needed to pursue the process. Working with the authors of this book, she learned that she could combine photos, rearrange formats, and generally change anything she wanted on her reference photos. This process of planning, in the past, had been done in her head, but now, with the help of the computer, she will save many hours of work. She plans to gain knowledge and experience on the computer and apply this information to her future works, using the computer as an editing tool for photos and drawings and a permanent tool for her own future painting.

F

Merging Water Backgrounds

"Just Ducky" by Penny Soto
watercolor, 14" x 23" (35 x 58 cm)

Penny Soto could be considered a colorist by all artistic terms. She looks for any subject matter that is filled with color, such as a fence filled with morning glories. Her inspiration and challenge is to bring out color and even to exaggerate it greatly in her paintings.

Penny has been using the computer already for developing her artwork. Her first step is to take photographs and put them in the computer to design her composition and do the value and color studies. She loves being able to put down glazes and to adjust and add colors with just the click of the mouse. Penny works in oils, watercolor, pastels, and airbrush.

The challenge of putting texture, color, shapes, and design into water using the computer was what Penny wanted to tackle in this session and she brought several photos with

water as a major element. In the past, she said she had been cutting up images from photos and color copies and rearranging them for her composition. Now, with the computer, this would not be necessary.

1. Penny's first step was to rearrange the positions of the ducks in the photos. Using Image B as a base file, we first enlarged the canvas size to give the ducks a little more space. More water was cloned into the white space. (Image C)

2. Next, we highlighted and copied the duck in Image A, and pasted it into Image C. Because the background of both files was similar, it could be roughly copied, bringing in some of the background water also. When it was pasted in the base file, while still on a separate layer, we could instantly see any

necessary color corrections we had to match the background of the two photos. Remember, we had roughly copied the duck so it brought in some of the water also. The two layers were then merged together. (Image D)

Penny wanted to make the water bluer, so we highlighted the entire background and altered its color slightly. When doing a big selection like this that has several values and colors, it is sometimes easier to select the images first (the three ducks) while holding down the Shift key and then select the inverse in the Inverse command. The selection was saved.

Finally, Penny thought the water should fade off slightly in the upper right corner, so we selected a pale blue, extremely transparent glaze and airbrushed some of the color over the water in that area.

A

B

A *A photo of a swimming duck.*

B *Two ducks sitting on rocks nearby.*

A lighter, green water reflection was added directly below the upper left duck and Penny felt she had enough information to start her painting.

As Penny did the painting (Image E), she made further adjustments in color and value. She zoomed in on sections of the water on the digital image so she could see the different shapes and colors within them. This made it easier for her to be more accurate when painting the final piece. Penny feels there are more opportunities to be creative and save time working on the computer.

When the painting was complete, she took a photograph and checked the colors, values, and shapes on the computer screen. This is an excellent way to check your colors and values. You can also view it in grayscale, if needed, to see things you normally wouldn't see. It works somewhat like viewing your painting upside down to help you to see shapes, not things.

Penny feels the computer is opening up a whole new world for the fine artist and it has inspired her to make many changes to her artistic process. She sees the computer as a great visual reference.

C

D

E

C *Here we add a little dimension to the existing photo to give the ducks some space.*

D *The three ducks have been placed in an attractive composition and the background waters have been merged together visually by matching the color and value.*

E *Soto's painting shows even more depth to the water.*

Adding Drama to a Scene

"Tempest" by Jane Hofstetter
watercolor, 21" x 29" (53 x 73 cm)

Jane Hofstetter says landscape subjects she has found while traveling and teaching have inspired her most. It is exciting to rearrange what the camera sees and records into a painting that has fine design and beautiful color enhancement. When she paints, her first goal is to establish big, medium, and small shapes, and dark and light values with a thumbnail sketch (Image B). Then, she establishes a focal point that occupies about twenty-five percent of the image. Finally, before painting, a color scheme is selected.

Jane said it was fun to think of Point Pinos Lighthouse, located near Monterey, California, back in the days when it saved many ships in fierce storms. She was excited to try this new way of developing such a historical landmark. Altering the lighting, environment, and mood of her subject so extensively requires a lot of preplanning. Creating it first on the computer will enable her to see her idea before she starts painting.

1. Jane told us she wanted to paint this image on a full sheet of water-color paper, which is 21" x 29" or a ratio of 1.38. We started with Image C as the base to her composition and estimated that the foreground rocks in this composition would take up about two-thirds of the width of the design, so we added to the computer canvas size, first to the length and then to the height to retain the 1.38 ratio. The computer image was now about 6" wide by 4.3" high with the cutout of the rocks shape about two-thirds of the width. You can see this relationship better in Image F.

2. In Image F, besides the foreground rocks from Image C, we added the lighthouse from Image A, rocks from Image D, and the water spray and some of the clouds from Image E. Each of these shapes was copied and pasted onto a separate layer, so we could move them around as desired. Jane also selected a stormy, blue gray color for a sky shape behind the lighthouse. We filled the sky with color using the Paint Bucket tool.

A

B

C

D

E

F

A *The historic landmark of Point Pinos Lighthouse near Monterey, California.*

B *A thumbnail sketch of Jane's compositional shapes.*

C *A photo of some rocks in the mist.*

D *A photo of some beach rocks.*

E *A photo used for the spray of water where the waves hit the rocks.*

F *A composite image is developed of the lighthouse set on rock. Note how the dark sky sets off the lighthouse and instantly changes the mood of the scene.*

G *Compare the big shapes in this final composition with the thumbnail sketch (Image B).*

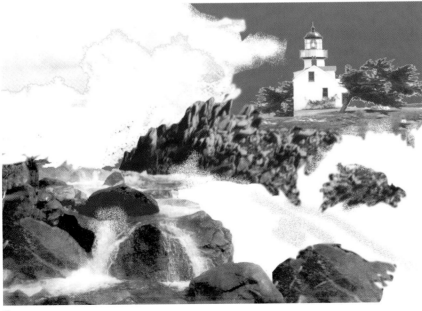

G

3. In the final computer image (Image G), we lengthened the pile of rocks below the lighthouse by selecting the shape and scaling them in the Scale command. We added another small pile of rocks by cloning them from the larger rocks, and added more trees to the left of the lighthouse by copying the trees to the right of the building and pasting them to the left and flipping them horizontally with the Flip Horizontal command. We copied and pasted these trees instead of cloning them because they needed to be on a separate layer so we could flip them horizontally. The lighthouse was "whitened" by adjusting the contrast (in the Brightness/Contrast command). Jane wanted to soften some edges and add the feeling of mist or water spraying over the rocks. To do this, we painted with a white Paintbrush, loaded in the Dissolve mode. Adding the mist, rocks, and dark sky all helped to create the storm atmosphere she was after.

The computer enabled the artist to successfully imagine what this scene might have looked like with a fierce storm and high seas blowing in, which no camera, she believed, could have caught. Jane found it exciting to establish shapes, values, and textures of the dramatic imagined storm and elaborate on them in her final painting (Image H). The computer allowed her to try many ways to paint that her imagination had not yet thought of. There will always be places though, where the artist's imagination will make changes because of his or her intuitive senses. Jane plans to work this way in the future.

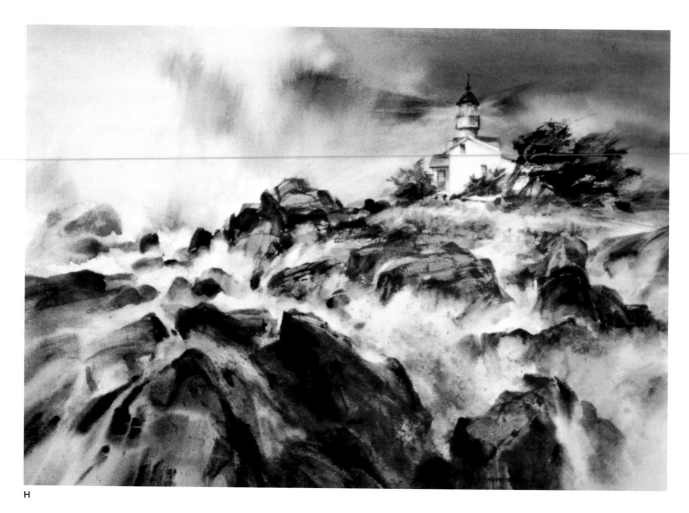

H

H *Watercolor is an excellent medium to express mist and fog. The painting definitely conveys that a storm is coming and the lone lighthouse is there to guide you.*

Combining Photos with Different Perspectives

"Fleuriste de la Rose" by Jann Lawrence Pollard
watercolor, 21" x 21" (53 x 53 cm)

When I travel, I find that if I walk, I see so much more of the country that I am visiting. Part of the appeal of Paris, especially in the fall, is the "magic" that happens as the sun is going down. A warm light bathes the streets as the lights are starting to turn on, and the sun turns everything a warm, soft glow. It was during one of those walks, when I came across this florist shop. The colors of the flowers were glowing, set against the rich color of the building, and the warm lights were beckoning me to come in.

When I photograph a scene, I make a note in my sketchbook and may even write or paint some color notes about my feelings of the subject. Because I am not a professional photographer, when I get my photos developed, they may not tell me why I took that photo. I don't want to just copy the photo, but translate it into my feelings on the subject, by eliminating detail and working with the essence of the subject. I try to help my viewer to see the scene as I may have seen or felt it.

Image A of the florist shop was taken from the wrong perspective for my painting. I wanted to do a view with a frontal perspective more like Image B to allow me to beckon you into the florist shop. I had also taken a photo of the back wall of the florist shop (Image C). Altering perspective, whether done in the computer or with a pencil or pen, requires technical perspective knowledge in order for it to look correct, just as you must know how to draw in order to properly use the computer as a tool for your compo-

A

B

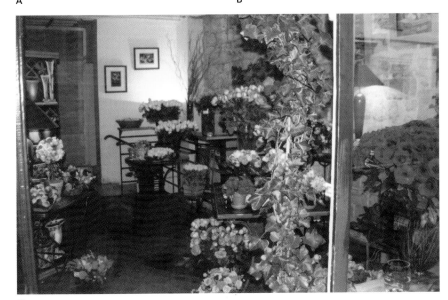

C

A *A photo of a florist shop in Paris.*

B *A photo of another Parisian florist shop.*

C *A photo taken just for the detail of the interior of the shop. I knew I would want this information when I returned to my studio.*

sitions. It is no different. Only the larger graphic software programs offer "perspective" as an option, but you can create similar effects with the less powerful softwares by using the Scale or Distort tools.

1. In Image D, I made my canvas size larger than the photo so I would have room to manipulate. With the Perspective command, I instantly changed the perspective of the front facade of the building. To do this, I highlighted the entire image in the Perspective command. A box appears with small handles at each corner and sides. You can move any of those handles and the perspective changes. I was not concerned with the interior of the shop because I would erase that and bring in the correct perspective from the other photo, on a separate layer.

2. Since the chair was now distorted, I highlighted and adjusted it to make it more correct from a

D

E

F

D *The facade of the shop has been altered to a frontal perspective.*

E *Only the facade, chair, and flowerpot were retained. The rest of the image has been deleted.*

F *A view of the layer with the warm, glowing interior of the shop. When the layer in Image E is turned back on, you have the shop front and the interior.*

G *A few more flower shapes were added to pull the viewer into the shop.*

H *In the painting, the glow of the interior of the shop was created by painting the wall in several glazed layers.*

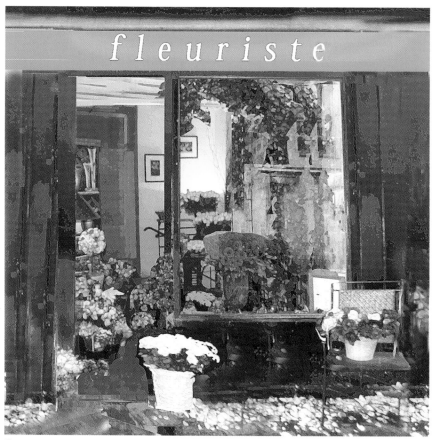

G

frontal perspective, this time using the Distort command to bring it back into perspective. If I had used the Perspective command, it would not have worked because I was starting with an image that was out of perspective. (Image E)

I erased the background by highlighting the interior of the shop and hitting the Delete key, keeping only the facade and the flowers in the windows.

3. Image F (only the shop interior layer is showing) shows how I was able to create the interior by copying the back wall of Image C, and then on a separate layer, copying the side wall of Image A and creating the "effect" of the side wall. When I altered the perspective, it distorted the objects on the side wall somewhat, but that didn't matter because I was only trying to give my viewer the illusion of some items on the wall. It filled in a "feeling" of the color and the texture of the shapes. I would not paint every detail.

4. A few flowers were cloned in from Image B, to help fill in the space to the left of the door and create a light shape for the viewer to enter the shop. After combining all of the layers, I only needed to add an awning. The awning from Image B was copied and pasted into the main file. The text that says "Patrick Allain" was cloned over with some of the surrounding color of the awning. Then new type was added that said "Fleuriste." For the type, I selected the Type tool set with white and typed the word "fleuriste." The effect is more "rigid" than you would paint it, but it gives you the effect of what the type will look like in your painting. (Image G)

By using the Perspective command, I was able to recreate the scene with the view that I wanted, and see if the relocated shapes would be cohesive and work in my composition. The Perspective command is one of the more difficult commands to master because you need a good knowledge of perspective to make your alterations believable. With practice in your drawing, it will become second nature.

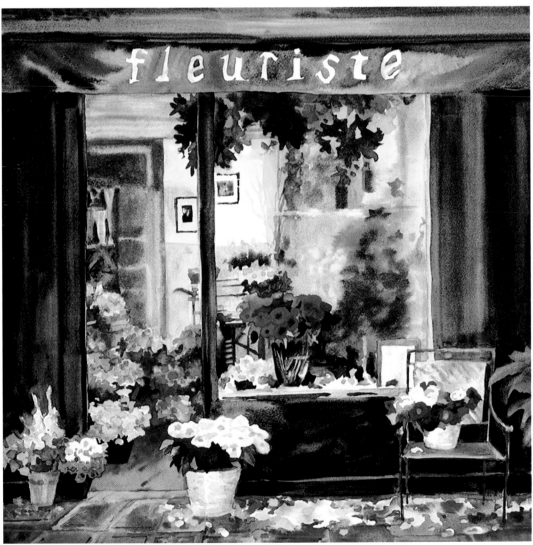

H

Using Repetition

"Berkeley Marina Boats" by Geri Keary
acrylic, 19" x 29" (48 x 73 cm)

Geri Keary and her husband own a boat in the San Francisco Bay Area, and are often found on the water. She is always looking for sources for marine paintings, and the Bay Area offers a wonderful assortment of boat shapes and scenic backgrounds. Sailing and fishing boats provide an artistic aura because of their body shapes and because the sails reflect so much of the water. The color of the reflections and water, slightly moving, excites her, especially in the early mornings. When the light is right, the reflections are beautiful.

Geri liked the general layout of the boats in her original photo (Image A) but wanted to add one of the boats in another photo (Image B) for a little color and interest (the far right boat).

1. But first, Geri wanted the boat on the right side of Image A to fill the empty mooring space in Image A. To do this, we lassoed the boat, mast, and its reflections and copied and pasted them onto another layer. Then with the Move tool, we moved it over to the next mooring. (Image C)

Then, using the Lasso tool, we roughly highlighted and copied the bright-colored boat in Image B (including some of the water) and pasted it onto a new layer in Image C. The boat was a little too large, so we selected it and scaled it down to match the scale of the other boats. The intensity of the colors, especially on the water, did not match in the two photos, so while still on a separate layer, yet viewing the layer underneath, we adjusted the colors of the water so they would match. The water and reflections on the new layer were highlighted and adjusted in the Hue/Saturation window, which allows you to adjust the hue, saturation, and lightness. Once it was set, we merged the two layers in the Layers Palette.

Geri didn't like the background trees, so we picked a color of the distant hill with the Color Picker tool, which loads your brush with that color. Then, we painted roughly around the masts to fill in the trees. It can be done roughly because it is only a sketch, which allows you to easily test ideas.

2. Geri wanted to lighten the sky, so she selected the sky shape with the Magic Wand, then selected two blue colors in the Foreground and Background of the Color Palette to be used with the Gradient tool to fill the sky shape, giving it a range of blues from left to right. (Image D)

With Photoshop, you can instantly turn your design to grayscale at the touch of a button to check your values. You will lose all of your color, but you can bring it back by Edit Undo or the History Palette or Revert to Saved. Just remember to bring the color back before you save the document again. In this and other programs, you can also save a copy of the image as a grayscale image. When she did this, Geri decided the boat on the far right needed a shadow on the left side, so we selected that shape and airbrushed a shadow with color picked from one of the other boats in shadow, using the Airbrush tool and a color selected with less opacity. The shadow made the boat pop more, making it look more realistic in its new setting. Geri painted the painting (Image E), adhering fairly closely to the computer sketch.

The computer helped Geri to arrange and eliminate certain unwanted scenes in the photograph. What made it interesting was how much the image could be enhanced, which changed the entire look of the finished painting.

A

B

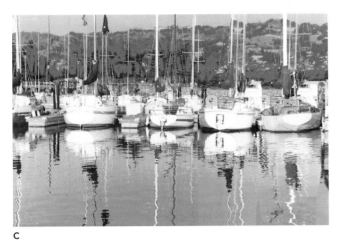

C

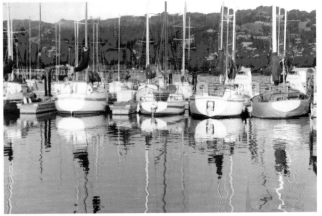

D

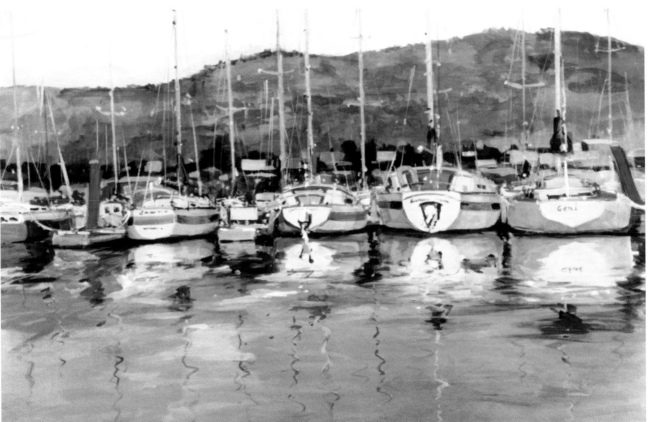

E

A *The arrangement of the boats needed to be changed for better continuity and design.*

B *The boat on the right, including the reflection, was copied and pasted into Image A.*

C *The empty dock space was filled in by moving the far right boat (Image A) into the space, and the far right boat (Image B) was then moved into that empty space.*

D *Much of the background detail has been simplified and colorless sky has been filled with color.*

E *Because most of the problems had been solved, Geri was able to complete her painting in a loose, painterly fashion.*

Scanning Sketches

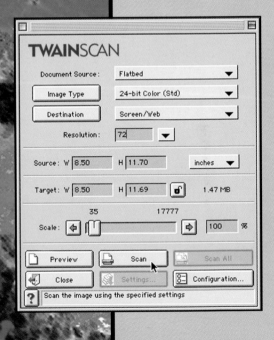

TWAINSCAN

Document Source :	Flatbed ▼
Image Type	24-bit Color (Std) ▼
Destination	Screen/Web ▼
Resolution :	72 ▼

Source : W 8.50 H 11.70 inches ▼

Target : W 8.50 H 11.69 🔓 1.47 MB

35 17777

Scale : ◀ |▯| _____ ▶ 100 %

Preview	Scan	Scan All
Close	Settings...	Configuration...

? Scan the image using the specified settings

Developing Color Studies

"Mushrooms" by Jerry James Little
watercolor, 13" x 17" (33 x 43 cm)

In addition to being great fun, using the computer to develop preliminary color sketches allows me to experiment with many more ideas than I normally would on paper. It is also very quick and easy to do. I usually do a series of paintings about a given subject. This painting was part of a series on mushrooms. I often save different experiments on the computer and then use them later for paintings.

1. The colors seemed weak in the original watercolor sketch on paper that I had done (Image A), so I used the Brightness/Contrast command to make the image stronger and added a bit more contrast. I also felt the right side of the design needed to be opened up. With the Lasso tool, I roughly highlighted the area and deleted some of the mushrooms and sky by hitting the Delete key. (Image B)

2. I still felt the colors were weak and not exciting so I made three copies of Image B (Images C, D, E), and proceeded to experiment with different color patterns, setting up the three images on the monitor so I could see them at the same time as a reference. Since mushrooms usually grow in dark forests, I was looking for a way to recreate that mood through color. A dark background would really set the stage for my painting. The Color Palette is located at the bottom in the Photoshop Tools. Simply click on the square box and an extensive selection of colors are available. Refer to your manual for a description of the various modes. You can also access colors by viewing the Color Swatches Palette.

In Image C, I used the Invert command, which in essence reverses all the colors that are highlighted, showing their opposites on the color wheel. Yellow becomes purple, red becomes green, etc. I also wanted to add depth to Images C, D, and E. After I drew in some background foliage and indications of more mushrooms, I glazed over all the background shapes to darken them slightly and to push them back into the background. Glazing can be done by reducing the opacity of the paint you have selected, and then painting with the Airbrush, Paintbrush, or other tools. In Images D and E, I experimented further with the color.

3. I decided to use Image C for the basis of the final painting (Image F). I made some additional design and color changes. In particular, I painted the upper right corner much darker than my sketch because I felt the composition needed that simple, large shape to create more depth, mood, and mystery.

Color is a key element to any strong painting and it will tell the viewer how you feel emotionally about your subject matter. I can create many color images on the computer in just a minute or two and then save them in a file for future reference. They provide solid reference information whether you end up doing a series of paintings or not.

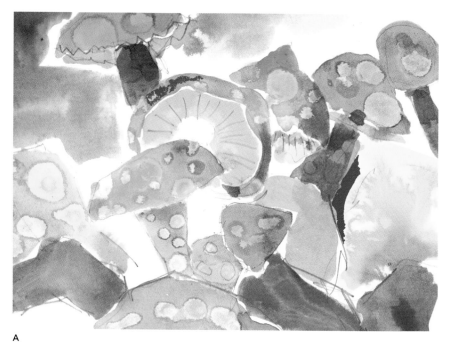

A

A *The composition and colors on this original color sketch were weak.*

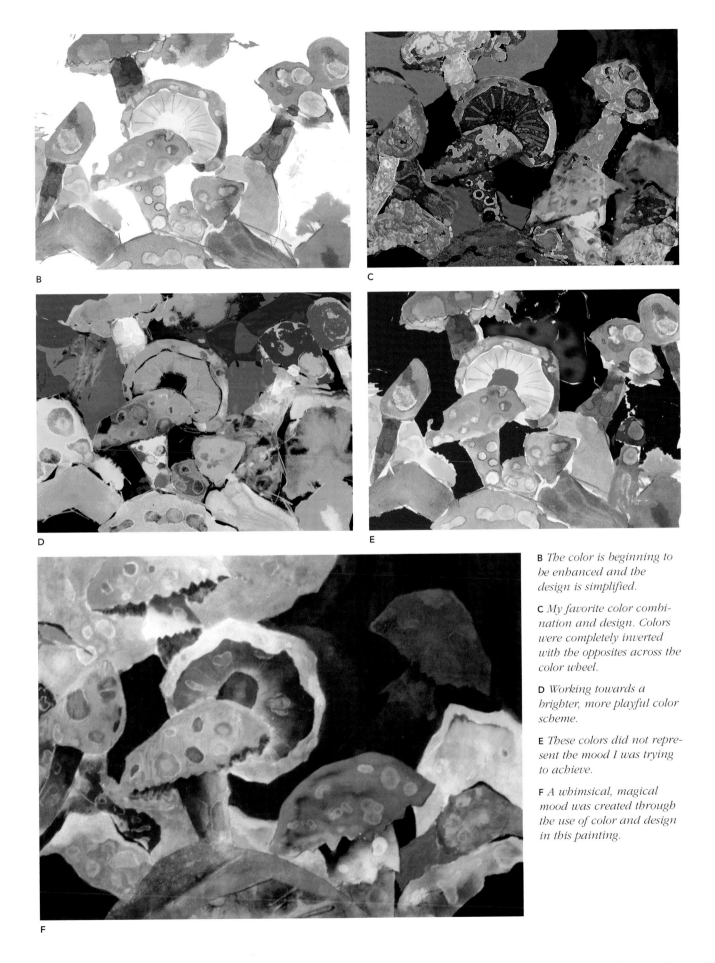

B *The color is beginning to be enhanced and the design is simplified.*

C *My favorite color combination and design. Colors were completely inverted with the opposites across the color wheel.*

D *Working towards a brighter, more playful color scheme.*

E *These colors did not represent the mood I was trying to achieve.*

F *A whimsical, magical mood was created through the use of color and design in this painting.*

Developing Color Studies **103**

Sketching in the Subject

"E-mail from Greece" by Pam Della
oil, 20" x 30" (51 x 76 cm)

Sometimes a unique situation will catch this artist's eye. Pam Della might see a group of houses coming through the fog on an Italian hillside, a high contrast of light beach umbrellas and people against a dark background, or the lighting effect on the mountain ranges near her home.

Working with pen or pencil, Pam does a few quick sketches and value arrangements. She likes to work in several mediums, with oil, pastel, and watercolor as her favorites. Working on canvas, she will wipe or scrub a turpentine wash over the canvas and lightly sketch in the main

shapes with a medium-size brush. She then blocks in value shapes with a thin color, so it can be changed easily. At this point, she proceeds with a heavier paint.

Pam traveled to a remote village in Greece and was interested to see if she could paint a glorious Bougainvillea vine (Image B) with the rest of the scene that she had photographed to add color and interest to the setting. Pam decided that she wanted Image A to be the main "base" photo, but first we had a lot of cleaning up to do. There were many extraneous elements and

Pam wanted to simplify some of the shapes. Also because of the camera angle, the porch columns and walls were not vertical.

1. We deleted both white chairs by cloning some of the stone floor over them. The entire porch area was then highlighted and rotated with the Rotate command so it would be vertical. Don't get the Rotate command confused with the Rotate Canvas command. The Rotate command changes only what you have highlighted. The Rotate Canvas changes the entire image. (Image C)

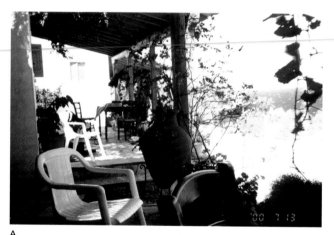

A

B

A *This photo as the base image was too busy and needed more color and cleanup of extraneous details.*

B *This brilliant Bougainvillea vine attracted Della and she wanted to add it to her painting.*

C *The entire floor area was highlighted and rotated to a more vertical position and the two white chairs were deleted.*

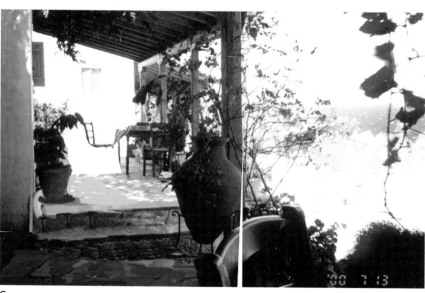

C

2. Pam noted that the porch column was in the center of the picture. She wanted to widen the verandah so it would occupy two-thirds of the width of her painting and the water would occupy about one-third, to make a better division of space. If we just scaled it wider, it would distort the scale of the porch so we copied a center section of the porch and pasted it onto another layer. Compare the width of the porch in Image C and Image D.

Then we highlighted the right side of the photo and moved it to the right, leaving a hole in the center. The pasted center portion of the porch, which was on another layer, was moved into the hole in the center, the two layers were merged together in the Layers Palette, and the top angle of the wall was aligned by cloning some

of the white wall over the space that did not match. Now the porch was wider, occupying two-thirds of the horizontal space. (Image D)

3. Some hanging foliage was painted at the ceiling level to soften the angled wall by cloning some of the foliage hanging from the porch. The Paintbrush tool was used to add to the cloned foliage, as well. The white wall was highlighted and filled with a softer white. Soft shadows were roughly painted on the wall with a purple color to break up the wall a bit more. More cleanup of extraneous foliage was done on the right side of the photo. Additional flowers were added around the pot in the lower right by repeat cloning of some of the flowers from Image A. (Image F)

The bougainvillea was copied

from Image B by highlighting just the flowers by selecting a range of pink colors in the Color Range command and adding to the selection where it was needed with the Magic Wand, while holding down the Shift key. It was pasted on a new layer and scaled to fit its new location. Because it is on a separate transparent layer, we placed the layer on top of the background layer (in the Layers Palette). We used the Eraser tool to erase any of the area around the bougainvillea that was not wanted.

4. Pam decided she wanted a figure at the desk on the porch, so she sketched a girl in a chair (Image E). We scanned the sketch, copied and pasted it on a transparent layer, scaled her to the correct proportion

D

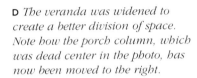

D *The veranda was widened to create a better division of space. Note how the porch column, which was dead center in the photo, has now been moved to the right.*

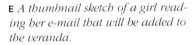

E *A thumbnail sketch of a girl reading her e-mail that will be added to the veranda.*

E

and moved her close to the desk. Pam felt that we did not need to color the figure in this computer sketch. She had enough information to begin her painting. She decided her canvas size was going to be 20" x 30", so we cropped the image proportionately. (Image F)

In her painting Pam added some olive trees that grow abundantly in Greece. She opened up the porch even more by deleting the back wall entirely and indicating more of the beach landscape. The figure has also been drawn a little larger to bring the viewer closer. (Image G)

Pam felt the computer offered countless possibilities for changes in placement, size, and color values, and far more quickly than she could accomplish with her pencil and sketchpad. Significant time was saved defining shapes and visualizing patterns of the composition and color patterns. She feels the computer will strengthen her oil, watercolor, or pastel work by simplification.

F *In the final computer sketch, the drawing was fairly rough and incomplete, but there was enough information for Della to start her painting.*

G *In the painting the figure was drawn a little closer to attract the viewer.*

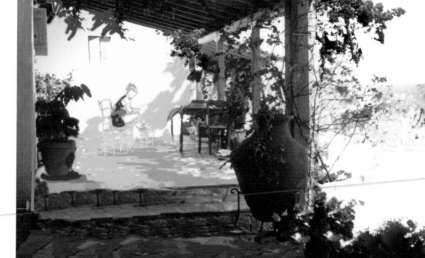

F

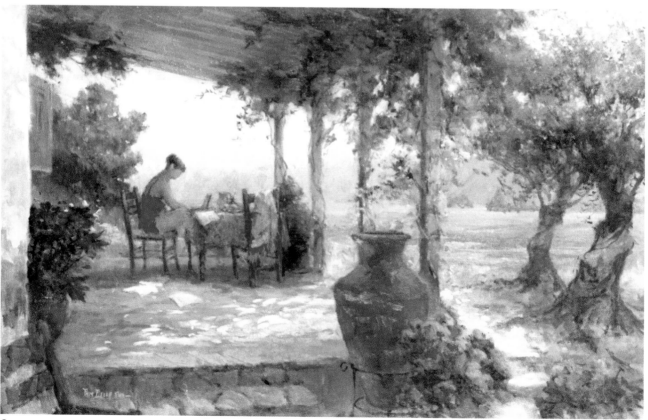

G

Creating Abstract Studies

"Portal and Parapet" by Gerry Willging
watermedia, 22" x 30" (56 x 76 cm)

A long time ago Gerry saw a still life and paint box in a friend's home. The next day she ran out and bought herself some "how-to" books and paints. That was thirty-two years ago. She told us that there are many reasons why she has to paint, but the most important one is the feeling of serenity and accomplishment she has when a difficult work comes together.

Gerry likes to work in acrylic for many of her pieces. She will initially do a drawing on a separate piece of paper. In this case, it will be a collage. She begins by adhering newsprint and tissue paper to watercolor paper or canvas with acrylic gloss medium. Layering continues with the addition of colored pencil, oil pastel, and stamping. She acquires texture by scraping through these layers and then adding several colors of acrylic, which are allowed to dry. Then, she will put alcohol onto selected areas, exposing variations of color and values. Her original sketch is now drawn onto the underpainting. The work is completed by painting in the large shapes and adjusting the values, by stenciling out some smaller shapes with alcohol.

Being an abstract painter, Gerry often studies realistic images strictly for their division of space. She may use these shapes (not things) as the basis for her painting compositions. She came to our studio with a simple line drawing, indicating where she wanted to divide the space. (Image A)

1. Gerry said she wanted to do this on a 22" x 30" piece of watercolor paper or a proportion of width to height of 1.36. Her original sketch in the computer file was 4.687" high by 5.12" wide. In order to retain the

proportions, we widened the computer file to 6.37" wide (Image B). A gold line was added to indicate a horizon line. This can be done by first selecting a gold color in the Color Palette, then selecting the Line tool and drawing a horizontal line set at about five pixels, while holding down the Shift key to keep it straight. Another way to do this same step would be to draw a long, very narrow rectangle with the Marquee tool and color it with the Stroke command at about five pixels. What this does is fill each side of the line with five pixels. In this same window, you select where you want the fill to happen—in the center, outside, or inside of your line. Again, this was done to help her see the divisions of space. (Image C)

A

B

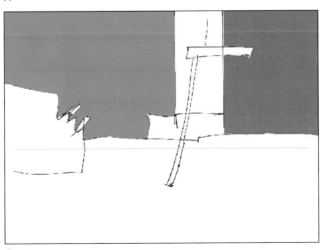

C

A *A sketch indicating an abstract design of space division.*

B *Canvas Size adjustments are made in this window. Note under the Anchor how you are able to place your image in any one of the nine areas of your enlarged canvas.*

C *Willging starts to work on the sketch by filling some of the shapes with color.*

2. In Image D we started filling each of the shapes with color by selecting the shape and using the Paint Bucket tool to fill the shape with color. Each was done on a separate layer, so we could move them around if she wished. At this point, Gerry felt this simple design held enough information to get her started on her painting. (Image E)

Working with a computer-imaging program was a true "breakthrough" for Gerry. It offers a comprehensive, yet creative option for beginning an abstract painting, using a planned approach rather than the artist's intuitive process of designing while working. Gerry enjoyed manipulating the elements into endless combinations with a click of the mouse, allowing her to visualize the final painting with more knowledge than before. At last, she has found another way for her to facilitate her love of experimentation. Her plans include learning more of this program for her art.

D

D *This very simple colored image was all the information Willging needed to start her painting.*

E *The painting reflects the basic simple sketch, but additional textural elements were added to the shapes to create interest.*

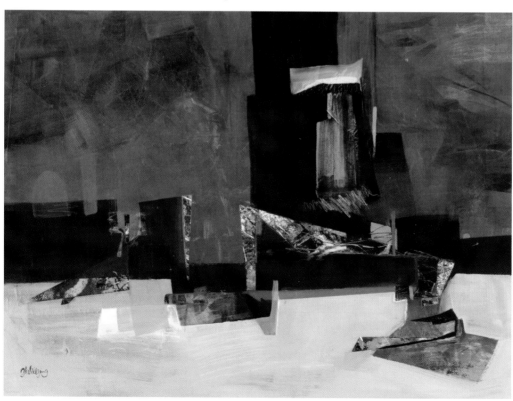

E

Using Figures for Structure

"Mario's Fish" by Margaret Evans
pastel, 15" x 23" (38 x 58 cm)

Through her work in watercolor and pastel, Margaret Evans hopes to give an artistic interpretation of the places she visits and people she encounters. Margaret likes to paint outdoors, so she can reflect on nature. Before starting a painting, sketches and value studies fulfill the task of setting the mood she wants to convey.

On one of her many trips to Italy, she stopped to paint in the small fishing village of Chioggia, near Venice. There, she met a fisherman named Mario, who would become the subject of her pastel painting. Two of her original photographs (Images A and B) were used for this painting, combined with a watercolor sketch (Image C) she made of Mario the fisherman on site. She used Image A as a base image.

A

B

C

A *Evans liked the collection of figures on the bridge and the background buildings in this photo.*

B *This little boy playing in the bucket will become the foreground element to take the viewer into the painting.*

C *A quick watercolor sketch of a fisherman from Evans.*

1. There were several elements she wanted to remove from Image A. She cloned over a bicycle and a head from the foreground, as well as extra wires, and the dark base of the building (Image D). As a foreground element, Margaret chose the little boy from Image B. The boy was copied and pasted into a new layer in Image A.

2. To fit the boy into the photo, she scaled him down in proportion with the background figures. She added a shadow beneath him to give him substance, by cloning the color from a nearby shadow area. The shadow was also put on a separate layer, so it could be moved independently, if necessary. (Image E)

Next, Margaret wanted to bring the Mario into the image. She flipped her sketch (Image C) horizontally by using the Flip Canvas Horizontal command. She copied and pasted it into the main image, which automatically placed him onto another layer. Mario was moved onto the bridge and reduced in size to the correct proportion. The bottom part of his figure, hidden by the wall, was erased with the Eraser tool so the bridge would show. (Image E)

To make the day brighter and warmer than it appears in the original photo, Margaret selected and blurred the background buildings with the Blur filter applied to just the buildings shape, then reduced the contrast. This was done to take them back in distance. The buildings on the left were given a warmer tone by making adjustments in the Hue/Saturation and Color Balance commands. This action brought these buildings a little closer to the viewer.

3. After doing this, the reflections in the water had to be brightened also. They were selected and the color balance was adjusted to match the buildings they reflected. Further color adjustments were

D

E

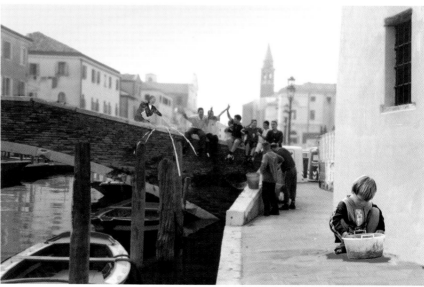

F

made, first to make the boy warmer, and then to brighten the sky, each done by selecting individually and making the adjustments. After selecting the sky area, she painted in a gradation of two colors (selected in the Color Palette) using the Gradient tool. (Image F)

4. Margaret made a copy of the file, which she turned to grayscale (Image G), in order to assess her composition in three values. It looked great, and became the basis for her painting! Margaret followed the computer study fairly closely, but altered the proportions slightly. (Image H)

G

D *The placement of the boy in the front helps to fill the void of the walkway.*

E *Adding Mario the fisherman to the scene helps to tell the story.*

F *The reflections on the water were highlighted to add more contrast.*

G *This image, viewed in only three values of gray, is a good example of how effectively large simple shapes work.*

H *Margaret elected to paint the figures just slightly larger to draw the viewer closer to the subject.*

H

Emphasizing Movement through Form

"The Dream" by Bob Gerbracht
pastel, 25" x 18" (63 x 46 cm)

Many things inspire Bob Gerbracht to paint. It could be the transparency and opacity of oil paints or the transparency of watercolor he has seen in another painting. It could be the use of thick paint applied so artfully that he would want to do it himself or it could be a person whose qualities are so unique that they should be documented.

Bob works in pastels, oils, and watercolor. Often, he will start his painting by drawing a small thumbnail sketch, working on placement and values. Other times, he will go directly to the canvas and try to resolve the composition in placement, value, and color with thinned paint and manipulate it by wiping out areas. Bob sometimes focuses on one section of the painting and finishes it, before continuing on. He unifies the painting by using movement, which takes advantage of the shape of the canvas, the forms in a painting, and their relationships. Movement provides a transition from shape to shape. It is a way to give order or rhythm to a design.

Bob came to our session with two fast, gesture watercolor sketches he had done several years ago at a model marathon (Images A and B) and a photo of a section of one of his large nude pastels (Image C). He felt the computer program might be just the way to further develop the artwork. He wanted to see how he could combine elements from different paintings and sketches into one image.

Bob determined that he would do this painting in oil or pastel, but wasn't quite sure of the dimensions. In this case, he went home with the computer printout and would cut his paper to match the proportions of the computer image.

1. Starting with Image A as a base, we selected the top figure, copied and pasted it onto a new layer so we would be able to move it around independently and then deleted the same figure on the layer

A

A *A watercolor sketch done at a model marathon.*

B *Another watercolor sketch.*

C *A portion of a pastel painting of a nude.*

B

C

underneath. The layer with the top figure was scaled smaller and relocated to a new position. (Image D)

The right arm of the dancing figure was not in the correct proportion so we drew her hand correctly and extended the right forearm with a Paintbrush tool, filled with the matching color of the hand. You can see this more clearly in Image F. Both of the figures were brought up in the Hue/Saturation and Brightness/Contrast commands.

2. Next, the watercolor male figure in Image B was copied and pasted onto a new layer in the main file (Image E). To easily highlight this figure in Image B, we used the Magic Wand to pick the white area surrounding him, then inversed the selection (Inverse command), and we instantly had the selection of the figure. This system will only work where you have a plain background. Once in the main file, the figure was scaled quite large, and moved to the right.

Bob wanted the figure of the pastel painting (Image C) to fill the entire background of the computer canvas. We copied the entire image and pasted it onto the main file (Image E). In order to "see" it in the stacked layers, it must be moved to the bottom layer of your Layers Palette.

3. The white surrounding the dancing figure in the original base file layer, also needed to be selected and deleted in order to see what was underneath it. Returning to the layer of the pastel nude figure, we scaled it to fill the entire background of our canvas. (Image F)

Now, we started manipulating the colors and values to coordinate the image. The colors were too bright and didn't coordinate well with Bob's color scheme. The male figure on the right was highlighted and the color and value transformed. We did this in two steps because first we highlighted the green part of the fig-

D E

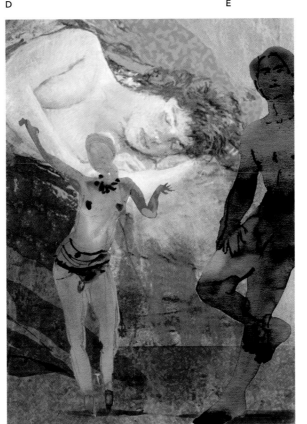

F

D *Note how the figure in Image A has been relocated and scaled smaller.*

E *The figures are beginning to create a sense of non-realistic space.*

F *Gerbracht has entirely created a new scene from some of his other watercolors.*

ure and changed it to a purple, then we highlighted the entire image and darkened the value. Placing the dark shape of the figure on the right helped to create a dreamlike feeling.

The background layer was brought down in value in the lower left area to make more contrast between the dancing figure and its background. Finally, the head of the large male figure was still too prominent, so we highlighted him again and airbrushed a darker color over his head area to soften the edges.

Bob wanted to create an effect of a wall and floor in the background, so we highlighted the bottom rectangle and airbrushed with the Airbrush tool a darker color where the floor would meet an imaginary wall to give the image a bit more depth.

To add some textural pattern to the red fabric of the background layer, it was highlighted and we applied a filter called Sponge, playing with the effect until we arrived at something Bob liked. We also applied this same filter to the floor area of the background, but this time we did it with only about a twenty percent transparency so it would have a softer effect.

Bob felt the computer could be the first step in creating a picture utilizing new ideas of color, texture, and design. As he worked on this pastel painting (Image G), using new avenues with some unforeseen results, an idea for a dream was crystallized. This artist feels the computer has inspired him to use the computer for more than just writing letters and keeping a mailing list, but it did not inspire him to work differently in his medium.

G *The proportions of the painting have been altered from the computer sketch, but the general shapes have been retained.*

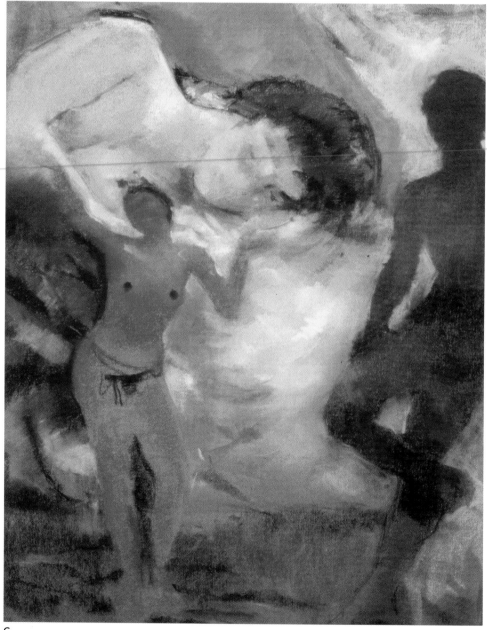

G

Drawing a Sketch on Screen

"DesignScape XII" by Jerry James Little
mixed media, 22" x 26" (56 x 66 cm)

I worked on a series of "Design-Scapes." In fact, I painted about thirty-five paintings in all, as they were so popular. The concept for these paintings was to present mountain range landscapes that would be recognizable to the eye but projected in an abstract way. I love to promote an idea rather than a specific subject at times.

1. Another way the artist can use the computer as a tool is to create an initial line sketch right in the computer. The nice thing about this process is you can delete or change any part of it without tell-tale lines on the paper. As most of my DesignScapes were done with-out the computer, I was very excited to do this one right from the beginning using a blank canvas on the computer. I started with the Pencil tool in Photoshop and drew my design. (Image A)

2. My next step was to experiment with different hues by painting them on the sketch until I came up with a basic color pattern that I liked (Image B). You can select colors in the Color Picker dialog box or in the Color Swatches Palette. I can work on this just as I would with regular paper, but without the mess of making color changes. I can check values, color, or contrast levels. All the things that make a good picture are there for me to use. While Image B gave me the basic design and colors I wanted, it lacked depth and tex-ture, and the values were still weak at this point.

A

B

A *An initial pencil sketch done directly on the computer.*

B *I started filling in the shapes with flat colors.*

C

3. To further define the image, I started to add more color, by strengthening the values (Image C). On the computer you do not have to wait for the drying period and your color is always fresh. In the upper part of the painting I added the depth and interest I wanted by drawing and painting the distant mountains. The Hue/Saturation command was used to soften the mountains and create a distant atmospheric effect. I also started to add texture using the Sponge and Noise filters, but only in certain areas. You can control the way you apply these filters with adjustments in the windows of each of the tools by varying the amount of pressure and the size of the brush. I also used the Pencil tool to further develop the crevasses in the rocks.

In the final painting, Image D, I made many additional changes on the upper mountain area and poured colored inks under the plastic wrap that I had manipulated to suggest the form. The inks tend to accumulate where the paper is creased and will become darker. The middle area was completed using modeling paste to suggest a cliff and give more depth. The rocks in the lower middle area were formed by using wax paper to create the cracks. Coffee grounds were also used to form the outer rocks.

By doing the computer image, I was able to visualize my final result much better. The computer image is only a tool to help you make fewer mistakes and develop more ideas. You can spend hours developing a painting on the monitor or just ten to fifteen minutes. Sometimes you may only want a design idea or only a color selection to look at. It is your choice.

D

C *This simply colored image was enough information to start my painting.*

D *The final painting was changed and strengthened in many ways, but the basic foundation had been made in my computer sketch.*

Developing a Black-and-White Sketch

"Magritte's Paris" by Jane Burnham
watercolor, 22" x 30" (56 x 76 cm)

Jane Burnham's joy is to get up in the morning, go to her studio, and retreat into her world of colors, shapes, and textures. As for subject matter, she has learned to see the many possibilities all around.

Jane paints in several water-medias. She usually starts her paintings doing a small newspaper-size sketch. She will continue to refine it until she is ready to paint. She also will take a digital photo and put it on the computer screen. This gives her the opportunity to try value settings and help develop the painting.

Jane says she had etched this scene in her mind the last time she was in Paris. She enjoys sitting at sidewalk cafes and watching people. Jane had done this sketch of a Paris cafe scene, but wasn't happy with it (Image A). She wanted to revise her sketch before she started her painting because the placement of the figures and the values were not correct.

1. First, she wanted to bring the figures out more, so we darkened the value behind them, by first selecting the shape and then filling the shape with a darker value of gray with the Paint Bucket tool. Because this background shape had been crosshatched, the Magic Wand tool could not be used. In this situation, the selection had to be made with the Lasso tool. We also put a simple mid-value behind the waiter and lightly glazed over some of the shadow shapes to emphasize them a little more. They appeared to be too light after we had darkened the large background shape. (Image B)

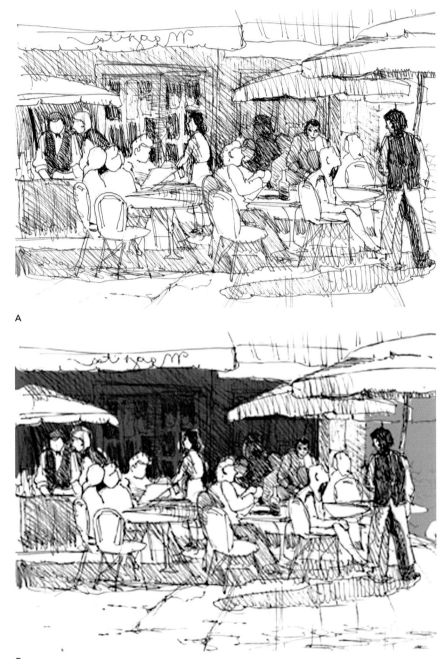

A

B

A *The original sketch from Burnham's sketchbook.*

B *The background shape has been darkened and simplified to give more depth to the image.*

2. In Image C, we glazed over the background awnings so they would create less interest. The vertical flap of the awning should be a value darker than its reflective top portion because it is receiving more light. This also brought less interest to the text on the awning. Jane didn't want the viewer to be concerned with what it actually said.

The waiter was too far to the right in Image B, so we highlighted the entire figure, pasted him onto another layer, and moved him to the left. The waiter on the original layer had to be cloned over with some surrounding texture and the table roughly drawn with the Pencil tool. An additional umbrella shape was added at a tilt behind the main umbrella to create a little more interest in those shapes. To do this, the umbrella shape on the far left was copied and pasted onto another layer. It was flipped horizontally, rotated, and moved into place.

3. Next, we also glazed a value over the back sides of the chairs by painting over them roughly with a gray value not at full opacity, which allowed some of the pencil lines to show through. We highlighted the waiter one more time and increased the contrast level a little to bring him to the center of interest. We checked the computer image size and cropped a little off of the bottom to maintain the same proportions of a full sheet of watercolor paper. (Image D)

When Jane started drawing her subject on a full sheet of watercolor paper (Image E) from the quick sketch and computer image, she realized the umbrellas "pinned in" the subject, so she added the awnings instead for the feeling of more space. She added and moved the figures around with her own computer until they felt right to her. Jane says this is part of the fun of interpreting a subject into a painting. The painting says what your inner self wants to say.

Jane liked making the many changes that the computer supplied. She enjoyed moving things around and working with the colors and values that were so quickly changed. After she has finished a painting, she likes to go back into the computer and see if she is satisfied with the outcome. Jane feels the computer has opened many windows for her to explore, and feels the possibilities are endless.

C The waiter has been moved to the left so he isn't so far out of the picture. Shadows have also been added and intensified to create more foreground interest.

D Jane has effectively reworked her sketch into another sketch without having to redraw the entire thing.

E In the final painting, the umbrellas were changed to awnings to open up the picture plane a bit more.

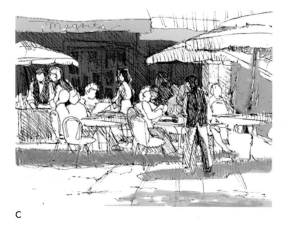

C

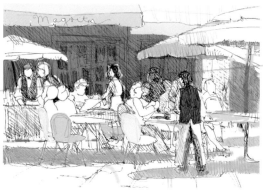

D

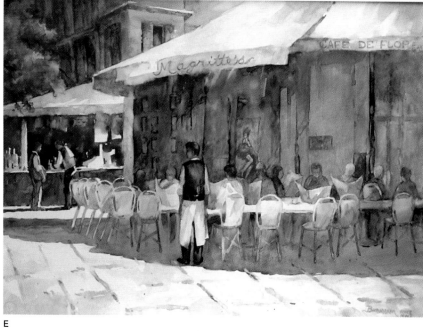

E

Combining Sketch Elements

"Mont Ste. Victoire, Provence" by Richard McDaniel
pastel, 8.5" x 11" (21 x 28 cm)

Richard McDaniel likes to work from nature. The visual elements of a landscape and the emotional or historic significance of a site attract him equally. Richard works in a variety of pigments and has no set way to start his work. As he says, "I like a bit of unpredictability." He enjoys making adjustments and compositional decisions during the painting process. Many times he starts drawing on location.

Richard is a "plein-air" painter and came to the studio with two, "on site" sketches he had done of Mont Ste. Victoire while in Provence, France. He wanted to see if he could create a new composition from his two sketches. He liked the trees in Image B better than in Image A, and wanted to try applying color to his sketch.

1. After scanning the sketches into the computer, in Image A, we cloned out the unwanted collection of trees with some nearby sketch texture using the Clone tool. (Image C)

A

B

A A sketch taken from McDaniel's sketchbook.

B Another sketch from his sketchbook.

C Using Image A as a base, the collection of trees that were not interesting have been deleted.

C

2. Then, we copied the three trees in Image B and pasted them into the Image C file, which was now our base file. Since they were pasted onto a separate layer, we were able to scale them larger to be just slightly taller than the mountain skyline. Notice that we also changed the height of the tree on the far right to make the collection more interesting. (Image D)

Once, Richard was happy with his composition, we used the Flatten Layers command in the Layers Palette to merge all of the layers together so we could start playing with some color and values. The sky shape was highlighted, Richard selected two colors, and a gradient was applied at a transparent opacity with the Gradient tool so we could still see the texture of the sketch lines underneath.

3. Next we highlighted the mountain range and painted it two colors of purple to blue. We picked the middle ground area with the Magic Wand tool to select it. Using the Magic Wand created a more natural selection and still showed some of the sketch underneath. Instead of filling the selected area with a solid green, it was painted in with a Paintbrush tool, leaving even more of a sketch appearance. (Image E)

4. The burgundy colors on the three trees, the foreground, and the teal blue shadow area were applied in the same manner as above. The dark color of the burgundy on the trees required that we then also select the shadow side of the trees and intensify the contrast in the Brightness/Contrast command to give them more dimension and weight. (Image F)

Richard made additional modifications as he did the painting (Image G). Mostly, he simplified the shapes even more in his pastel to help create a deeper feeling of the landscape. Of the computer session, he liked the way it was so simple to make adjustments and explore different concepts with no risk to his original drawings. He liked being able to create this pastel painting using his drawings and the computer printouts as an additional source of information. Richard feels the computer can help him acquire information to develop more successful paintings.

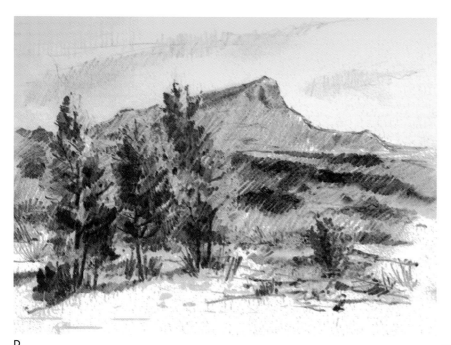

D

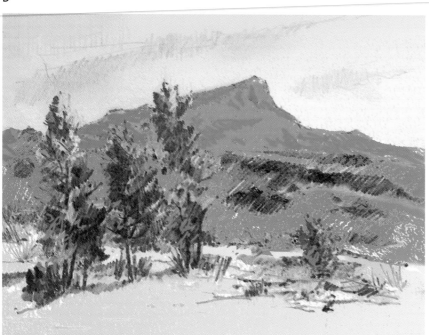

E

D *Color added directly to the sketch eliminated the need to do another small colored sketch.*

E *Adjustments of color and values in the simple shapes begin to give some dimension to the mountains.*

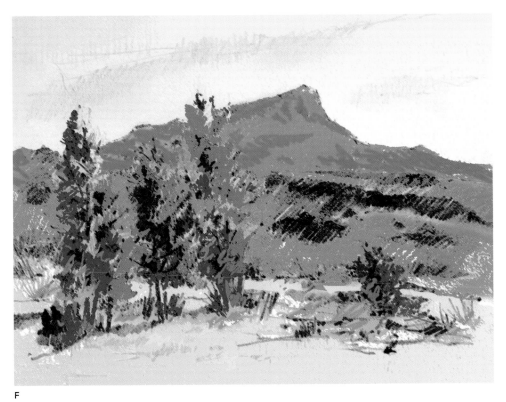

F *The new colored sketch with the contrast improved.*

G *In the final painting, the mountain range has been lightened to take you back further in the distance. Your eye can just leap into this painting.*

F

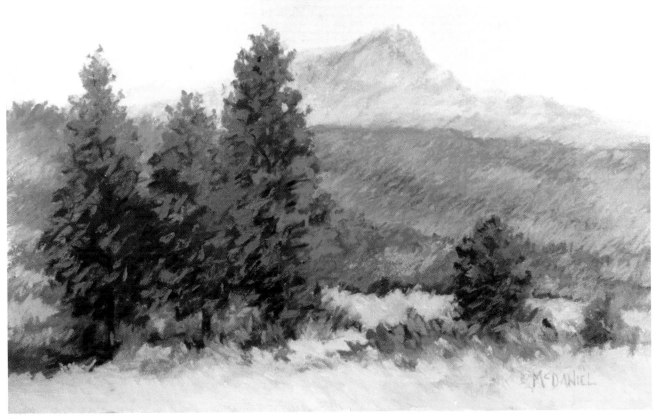

G

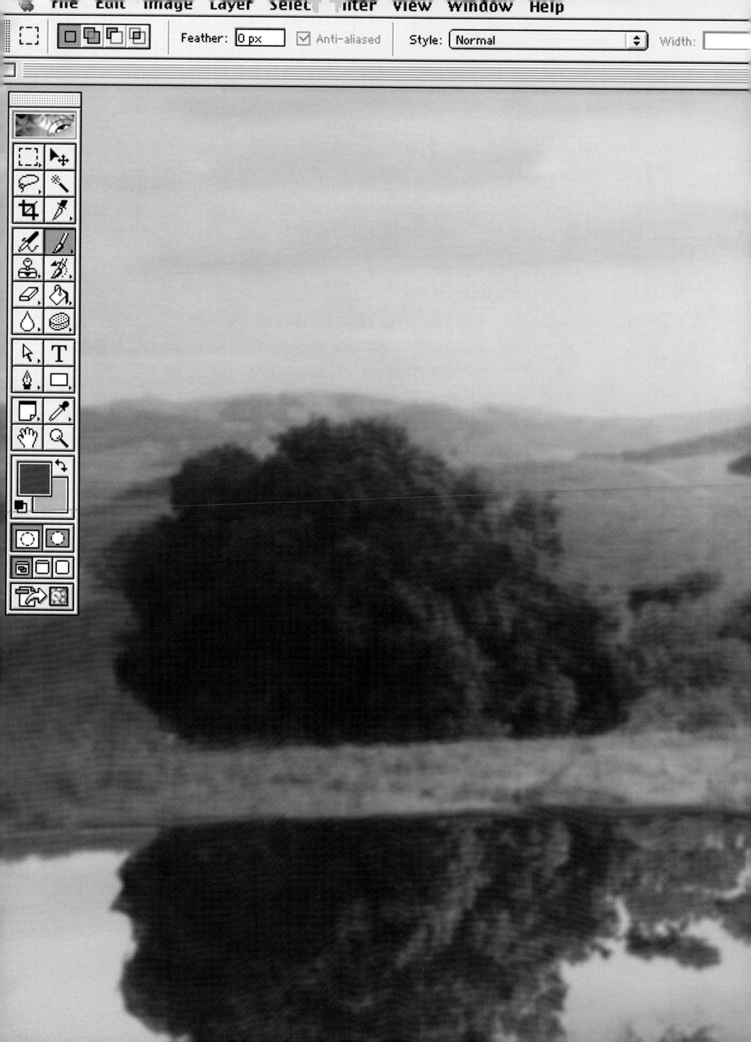

Using Digital Effects

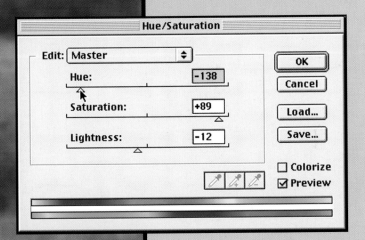

Creating Reflections

"Rock Creek Canyon" by Dale Laitenen
watercolor, 22" x 15" (56 x 38 cm)

Drawing on the rugged topography of the western United States, Dale Laitenen creates a blend of representation and abstraction in his landscape painting. The inspiration for *Rock Creek Canyon* began with a photo taken in the Sierra Nevadas (Image A). Laitenen was drawn by the contrast between the rugged granite and soft meadow grasses. He wanted to see if he could create a lake with a reflection of the rock formation in the place of the meadow.

Usually, he begins a watercolor with either a line sketch or value study. Once satisfied, he draws his sketch onto watercolor paper, which he uses as a guide for the painting. He uses large washes and big brushes before moving on to greater detail. To complete a painting, Laitenen usually paints several layers.

1. In the original photo, the main rock lay in the dead center of the composition. In order to play with its position, the rock was copied and pasted onto a new layer, moving it to the right. (Image B)

2. In order to increase foreground interest, Laitenen decided to replace the grass with reflecting water. He duplicated the Background layer with the Duplicate Layer command. This is always a wise thing to do when you start moving things around. Then he merged the Rock layer and the Background Copy layer together with the Merge Visible command, making sure that they were the only visible active layers. (Image C)

Laitenen felt the image was too blue-green, so he adjusted the color balance of the group of trees to the left of the main rock by selecting them and bringing out some warm reddish colors in the Color Balance command.

With the Rectangular Marquee tool, he copied a horizontal section across the middle of the image down to the base of the rock and pasted it onto a new layer. He flipped this layer vertically and moved it down to make a direct reflection of the rock above. He moved this Reflection layer down between the Background Copy layer and Background layer. It is not visible, however, until the next step is completed.

On the Background Copy layer, he drew roughly what would become the approximate water shape of the lake with the Lasso tool (leaving a few grasses as in Image C), and deleted this shape

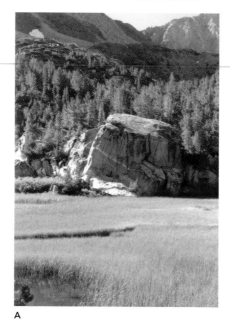

A

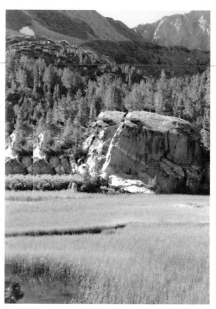

B

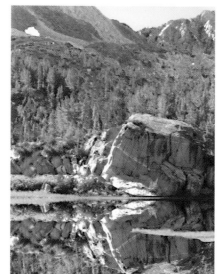

C

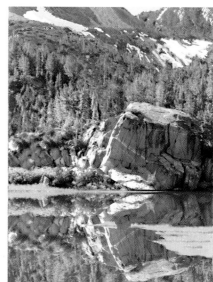

D

with the Delete key. When the grass shape was deleted the Reflection layer was exposed in the layer underneath. Then, with the Eraser tool, he fine-tuned the shape around the grasses.

3. Because the mountain in the photo lacked depth, Laitenen decided to add interest to the distant mountains, so additional areas of snow were painted with the Paintbrush and the Clone tool, which gave the mountains a highlight. Their value was lightened in the Brightness/Contrast command to make them recede more. (Image D)

Then he painted red foliage at the base of the rock. For the reflection of the red foliage, it was copied, pasted, and inverted with the Flip Vertical command, and moved with the Move tool, directly below the red foliage.

The appearance of water was created much as it is done in a painting, by softening the colors of the reflections. Laitenen selected the reflective areas of the water and a thin cobalt blue glaze was applied to it by painting the shape with a soft Paintbrush tool at a fairly transparent opacity. We could have also used the Airbrush tool to accomplish the same thing. A larger green grass shape was cloned over the water on the right side.

The computer image gave Dale the confidence to create a lake instead of a meadow in the final painting (Image E). When you move objects and shapes around, it changes the composition considerably. Whereas the meadow was a light-colored shape, the lake has become a dark shape. These changes affect the entire painting composition.

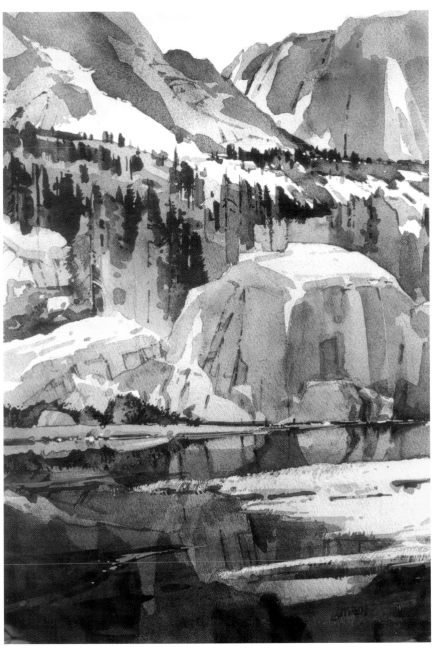

E

A *A photo of Rock Creek Canyon in the Sierra Nevadas.*

B *The main rock has been moved to the right on a new layer. The duplicate rock still shows underneath.*

C *The foreground meadow has been replaced with a lake and the reflections have been added.*

D *By lightening their values, the distant mountains recede more. The addition of snow shapes adds visual interest.*

E *The completed painting plays on the rugged terrain even more with the application of the strong square brush strokes.*

Creating Soft Edges

"West Marin" by Donna McGinnis

oil, 36" x 48" (91 x 122 cm)

The beautiful vineyards, rolling mountains, and streams that are all part of Sonoma County in California inspire Donna McGinnis. In her representational images, she looks for the mystery and beauty in everyday-life objects that have interesting shapes, colors, and textures. Her idea is to make humble objects into heroic portraits.

Donna works in watercolor, oil, pastels, acrylics, and pencil. She usually starts painting on a blank canvas without sketching and usually starts with a vague idea of the horizon line. She will often work on several paintings at one time, putting thin glazes on each one and allowing them to dry. This way, she does not have to wait for the artwork to dry.

1. The photos she used for this painting came from a place near her home where she often hikes. Donna wanted to do a large oil painting on a 36" x 48" canvas (or a proportion of width to length of 1.33). We scanned Image A, which was 4" x 6". If she wanted to retain the full width of the photo, the height would have to be 4.5" in the computer file to keep the proportion of 1.33. We added a half inch to the top of the file and cloned in some of the surrounding sky color to fill in the blank space. (Image C)

Because the water (soon to be added from Image B) was angled in the opposite direction, the image needed weight on the left side, not the right side, so the

entire image was flipped horizontally. Then we copied the reflecting water in Image B and pasted it into the main file. The angle of the front bank of water was adjusted through the Skew tool. We also deleted both of the grassy islands in Image B by cloning some of the reflective water over them.

2. Donna decided to put some clouds from Image D in the image, but after copying, pasting, and manipulating them on a separate layer, she decided she did not like them. She had the option to just "turn off" the layer while she continued working on her design, but she felt fairly certain that she no longer wanted the clouds, so we

A

B

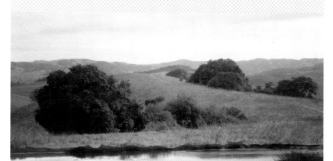

C

D

deleted that layer entirely. (Image E)

To add the tree reflection in the water, we highlighted the main tree shape and some of the surrounding foliage, then copied and pasted it onto a new layer. Then, we flipped it vertically in the Flip Vertical command and moved the inverted reflection in place in the water.

3. After flattening the file in the Layers Palette (compressing all of the layers into one), we started playing with the color saturation, brightness, and contrast to achieve the effect Donna wanted. Donna shifted all of the colors to a limited palette of warm colors. She paints in an impressionistic manner with a limited palette. (Image F)

Donna said that because of the way she works, particularly in oils, an image takes days to dry while it is being formed. By using the computer, she would be able to make instant changes and corrections, saving her lots of valuable time. She felt it was a more direct approach to painting. The completed artwork reflected several more changes that she made as she painted. (Image G)

Working with the computer has inspired this artist to upgrade her own computer and use Photoshop. She is also considering buying a digital camera. Donna usually does not paint from photos, but now intends to explore this avenue for her future artwork.

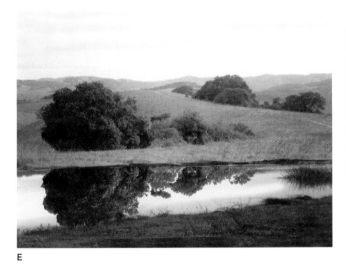

E

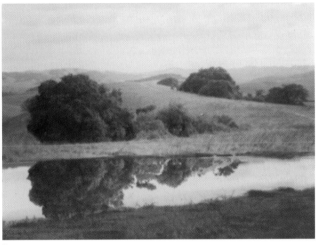

F

G

A *A landscape photo of the Marin hills near San Francisco.*

B *A photo of some water in the Marin hills.*

C *Images A and B have been combined in a new setting with the marsh grasses removed.*

D *A photo used for the cloud shapes, but later McGinnis decided not to use them.*

E *The water is now reflecting the bush shape and foliage above it.*

F *Colors in the image have now been adjusted to a limited, warm palette.*

G *McGinnis painted the scene with an impressionistic style, softening the edges and colors even more.*

Adding a Light Source

"Venetian Sunset" by Jann Lawrence Pollard

watercolor, 20" x 23" (51 x 58 cm)

Venice is a painter's paradise—a city like no other. After looking through my photos from a trip to Venice, I decided to paint one of the fantastic sunsets of Venice, but my photos were mostly shot in the daytime. I wanted to recreate the sunset and mood that I had felt.

My plan was to take a busy scene and turn it into a sunset scene void of much detail.

To recreate the sunset and mood, I began by making a compositional study (Image B) from a photo (Image A). This quick sketch helped me to visualize the pattern of large simple shapes and gave me an indication of where I should crop the photo. I often combine a simple sketch that I have done on a trip with my photos. I sketch to help register my feelings about the subject I am seeing.

A *This original photo of the Grand Canal showed an active daytime scene.*

B *I did a very quick thumbnail sketch to clarify the simple shapes in my mind.*

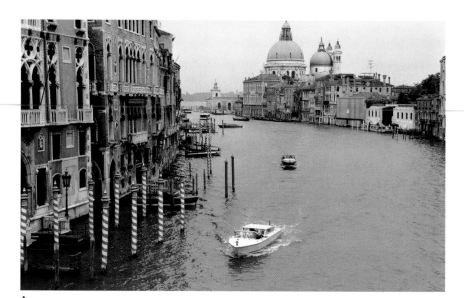

A

B

1. I created an empty Photoshop file with the same proportions as the sketch. After cropping the original photo to approximately the same proportions as the sketch, I copied the cropped portion as shown in Image C and pasted it into my new empty file (Image D). Next, I selected the pasted image and scaled it to the approximate placement and proportions of my sketch, which left a blank space at the top. You do this by applying the Transformation in the Scale command. The white sky area was filled with the color of the sky, which I had chosen using the Color Picker to determine the color and value. The buildings on the left were made taller by selecting and scaling them slightly taller to fill in the empty canvas space by using the Distort command.

My quick sketch showed the buildings on the right larger, so I highlighted those buildings and scaled them larger to match my sketch. I also increased the scale of the rear building and scaled the distant island shape higher to bring more emphasis to it. In essence, I brought the distant island and building closer to the viewer, which also helped to fill in some of the center sky shape that was too dominant.

Some of the boats were removed by using the Clone tool, cloning some of the water over the boats. I intended to create a serene sunset and did not feel the activity of the boats added to the scene.

2. At this point, I was ready to start playing with the many options offered on my software program. I knew I wanted my final image to be very warm in color and moody to indicate a sunset, so I tried different options in Curves (an adjustment tool in Photoshop that lets you vary values, colors, and posterization). The Posterize command automatically divides the range of 256 values into as few colors as you select, to display a simplified design. The group of buildings on the left and the right were posterized separately, so I could control the amount of

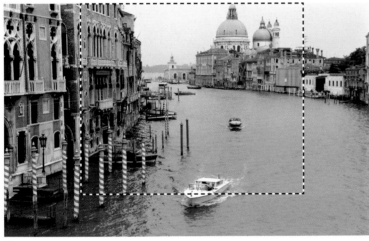

C

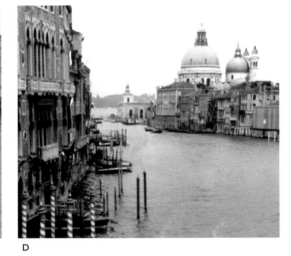
D

E

C This image shows the crop lines that match the proportions of my thumbnail sketch.

D Additional space was added at the top of the file and the distant building and island were made larger to help fill in the sky shape.

E This step shows the scene has been simplified, but the edges are still too hard and the colors too intense for the mood I wanted to achieve.

Adding a Light Source **129**

posterization done to each grouping. Then, I adjusted the brightness and contrast with the Brightness/Contrast command and desaturated the colors with the Hue/Saturation command. (Image E)

3. The sky still needed some mood. First, the sky shape was selected with the Magic Wand tool, then two colors were chosen in the Color Palette for the sky—a reddish warm value and a lighter yellow value. The sky shape was filled using the Gradient tool with the redder color on the bottom of the sky and the lighter yellow towards the top. You control which color you want at the bottom of the gradient by the direction you are holding and dragging the mouse. Then, a white circle was added to indicate a sun by highlighting a round shape with the Circular Marquee tool. If you hold down the Shift key, your circle will remain a circle, not an oval. The circle was filled with white with the Paint Bucket and the Airbrush tool was used with a warm yellow to soften the edges, and some soft yellow lines were painted through it with the Pencil tool to indicate warm cloud shapes. (Image F)

The edges of the building groups were still too hard and showed too much detail. I selected the building groups with the Lasso tool and then, with the Airbrush tool, glazed over their edges with several layers of color, to soften them, much as you would to a painting. I chose lighter colors for the group of buildings on the right, since they were further in the distance.

I felt that the green in the image was still a little strong, taking away from the overall warmth I wanted to achieve. I desaturated just the greens in the Hue/Saturation command. In this window there is a pop-down menu to edit the greens, with a Saturation slider to take color out. A few more highlights to the reflection shapes were added by cloning them from a nearby

reflection. (Compare the reflections in Image E and F to clearly see where they were added.) To give the final image the look that was wanted, a filter called Noise was applied that gives it a soft, textural effect.

Having done this design on the computer enabled me to paint with confidence. (Image G) I don't think I would have attempted this if I had not done this preliminary computer composition. Fear of ruining your painting often keeps you from testing some of your ideas.

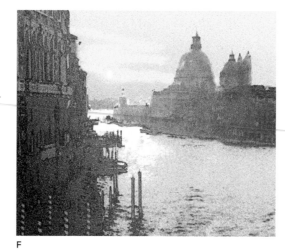

F

F *Applying a filter called Noise instantly softened the edges and created a mystic atmosphere.*

G *The final painting closely mirrors the atmosphere created by the computer filter.*

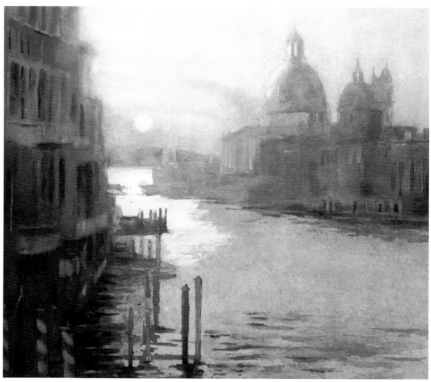

G

Exaggerating Proportions

"Sunflowers" by Jean Warren
watermedia, 29" x 21" (73 x 53 cm)

Jean Warren's insight for art is about discovery and response, reacting to the emotion or rhythm of the subject, and directing the eye through the painting. She looks for shapes and patterns that may evolve into a somewhat abstract form. Jean likes to do quick design sketches, playing with the shapes to determine her subject matter and focal points. She likes to put down what she calls "rhythm washes" of transparent watercolor to establish the movement. Color is intuitively chosen as she responds to the subject matter.

Jean was very interested in what the computer could do to further develop her artistic talents. She brought several photos of sunflowers that she had taken and narrowed her selections to three photos that she wanted to combine into a painting. She wasn't sure of the size of the painting that she wanted to do, so we created a large master file so she would have plenty of space to work with her images.

1. First, we highlighted just the sunflower and its leaves in Image A and copied and pasted it into the master file. We added to the top of the flower shape by cloning some of the petals. We then rotated them and placed them in position on a separate layer and merged the two layers together. (Image C)

Next, we highlighted the flowers and leaves in Image B. A quick way to highlight a complicated image like this is to select a range of colors on the blue sky in the Color Range command, then inverse the selection and all of the flowers are selected. These were pasted into the master file onto a separate layer. Jean wanted to play with these shapes, so we distorted this selection to be more elongated in the Distort command. You will also note that the large flower was desaturated and lightened to push it back in the space in the Hue/Saturation command. At this point, Jean decided she wanted to make this a vertical painting of 29" x 21", or a proportion of 1.36. We scaled the master file accordingly.

A

B

C

A *A photo of a sunflower.*

B *Another photo of some sunflower shapes.*

C *The sunflower shapes of Image A and B have been placed in the empty canvas and distorted and lightened.*

2. Jean decided to bring in some additional flower shapes from a third photo (Image D). A selection of these flowers was done in the same way as in Image B, then pasted into the master file. She wanted to see them flipped, so we applied the Flip Horizontal command to that layer and then erased some of the extra leaves on the right with the Eraser tool. The saturation and lightness were also adjusted. (Image F)

For the background, we created a new layer, with which we tested various background colors with a Gradient fill, much like a gradient wash is done in watercolor. Several of the layers were tweaked with the Saturation and Lightness tools to push some of the flower shapes back in the space even more. (Images E and F)

To retain the proportions of a full sheet of watercolor paper, the empty space at the bottom of the image had to be filled in by cloning some of the flower shapes directly above. (Image F)

In her painting, Warren was able to achieve a more transparent effect of the distant sunflowers with watercolor, and she elected to give the image some weight at the bottom with the addition of some dark shapes and colors. (Image G)

At first, Jean felt this process of scanning photos to paint from seemed too confining or predictive and did not allow for creative expression. It turned out just the opposite! She found it to be like a sketchbook that allows you to maneuver the shapes, simplify, add, subtract, flip, and distort. It was great to be able to save the original thoughts without erasing them. She especially liked being able to desaturate or fade images in the background and to see values each step of the way by looking at the design in the Grayscale mode. Another way to view it as grayscale is to desaturate the colors in the Hue/Saturation command to quickly

view them, then undo that step immediately and your colors will reappear. The versatility is endless and she found that color choices could be explored in depth.

Jean noted that while painting, the artist is free to respond to what the paint is doing on the paper. If the painting dictates a different direction, she consulted the computer to see if this new idea would work as well as the original one.

D

E

F

D *Still another photo of some sunflowers.*

E *The Layers Palette showing how the sunflower images were placed. It is important to keep your background layer on the lowest layer so the sunflowers can be viewed on top of it.*

F *Saturation and lightness were adjusted in the final computer image.*

G *A more transparent effect of the distant sunflowers was achieved in Warren's painting.*

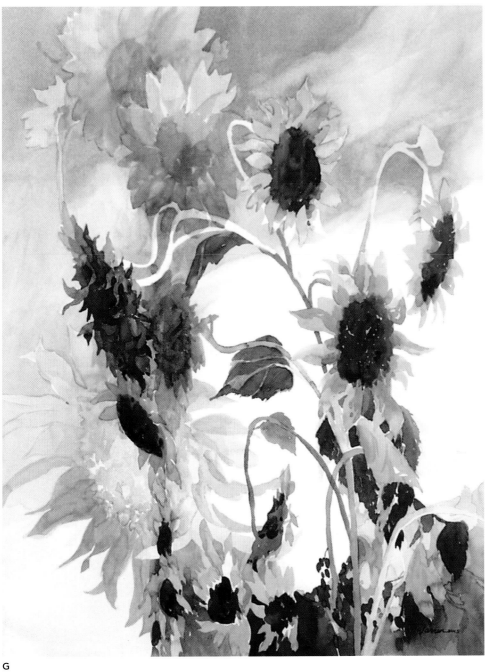

G

Using Filters in Layers

"French Village Architecture" by Jann Lawrence Pollard
watercolor, ink, and watercolor pencil, 12" x 12" (30 x 30 cm)

Image A is a photo I took of a French village in Burgundy. I was attracted by the shapes that the light formed as it hit the buildings. The street scene, however, was too dark and lacked color. When I returned to my studio, I was reading a book about J.M.W. Turner painting in Venice with inks, watercolor, and gouache, so I thought I would try some of his techniques on this image. But first, I would test the idea and composition on the computer.

1. Because the people in the street didn't really contribute to the composition I envisioned, I cropped the photo to a square shape, completely deleting the bottom part of the image. My "story" was about the light on the rooftops. (Image B)

I intended this work to have a line/sketch quality, much like Turner's work, so first, I duplicated the entire square-shaped image and pasted it onto another layer in the file. I now have two images exactly on top of one another. To the top layer image, I applied a Photoshop filter, called Find Edges (or it might say Trace Contour in another software), which gives a line quality. Then while still in this window, I brought the transparency down to about thirty-eight percent so I could see the image underneath, yet still retain a line quality.

2. To keep the image on the bottom layer simple and void of detail, I highlighted the entire image and adjusted it by using the Posterize command to about five levels of value. This helps delete extra elements and simplify the image. Next, I used the Blur filter on this same layer to capture just the simple shapes. This step works much like squinting at something in order to see the simple shapes. I decided I liked the general design of the light shapes. (Image C)

3. The original photo hardly showed any color in the sky, so I filled the sky with a pale blue color by highlighting the shape and filling it with the Paint Bucket tool, keeping the value of the blue fairly light, yet slightly darker than the lightest shape on the building on the right to emphasize it more. I now can view the two stacked layers together. At this point, I have captured the feeling that I wanted and am eager to get to my brushes. (Image D)

A

B

C

D

A *A photo of a French village street scene.*

B *A computer line drawing of the now cropped image.*

C *A blurred view of the image seen through the Blur filter.*

D *The two layers of Images B and C combined. Note how the blurred shapes help define the composition of the line drawing stacked above.*

Since I wanted the actual painting (Image E) to have a "sketchy" Old World feeling, I sketched the image loosely with various inks and water-soluble colored pencils. Then, I decided the colors would be a limited palette, much like the photo.

My concept was more about the light on the architecture, and text will often pull your eye to it. I purposely played down the sign on the building by keeping all of the shapes surrounding it close in value, so the eye would not go there. With the computer sketch as my guide, I could sketch and paint quite loosely and still achieve my objective. I have found that if I do this preliminary planning, it frees me to enjoy the painting process so much more.

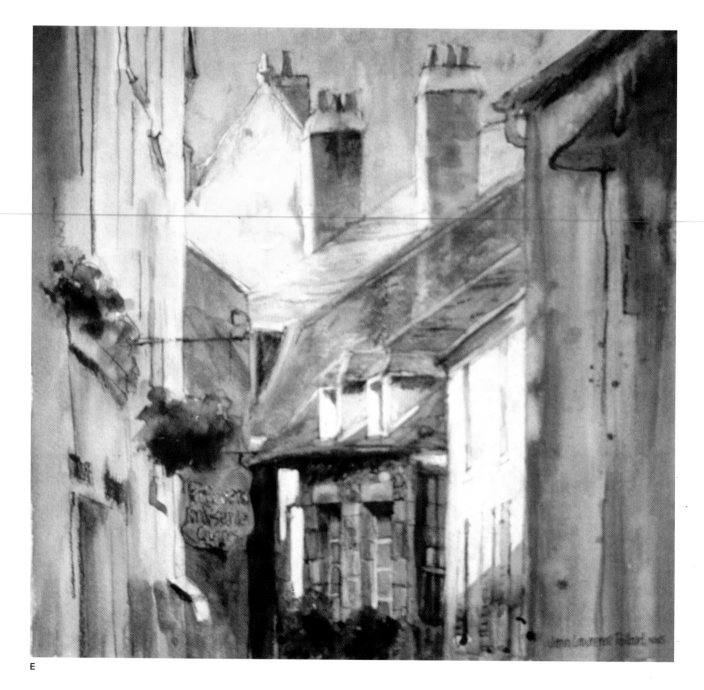

E

Fine-tuning Architectural Details

"Northleach Village in the Cotswolds" by Jann Lawrence Pollard
watercolor, 21" x 29" (53 x 73 cm)

I have a definite passion for the historical villages in the Cotswolds in England. The years of wear on the stone create some wonderful textures and colors. Even the leaded glass windows create texture with their irregularity.

These photos were taken in the wool town of Northleach in the Cotswolds. Often photos may include unwanted cars, antennas, or people, and the lighting may not be perfect. (We all know the British weather.) Earlier that day, there had been some wonderful soft shadows from the buildings and they were now gone, but with the magic of Photoshop, you can easily correct these elements.

I liked the general street scene in Image A, but it has too many hard edges, too much asphalt road, and the sky shape is quite uninteresting. The building on the right is interesting, but the buildings down the street get lost in the composition.

A *A photo of a street scene in the Cotswolds in England.*

B *A closeup view of some flowers.*

C *Another photo of a street scene used strictly for the Bed and Breakfast sign.*

D *Another Cotswold street scene used for the foreground wall and tree branches.*

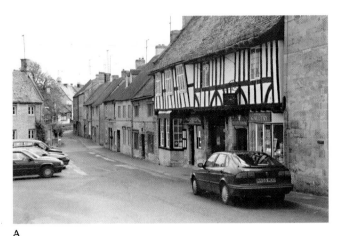

A

B

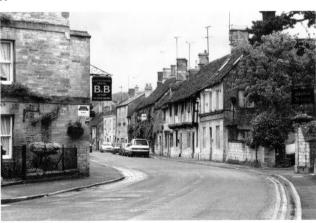

C

D

1. I started out by cleaning up Image A. Image E shows how I started to take out the cars by cloning some of the surrounding texture over them using the Clone tool. As you are drawing with the Clone tool, you must continually alter the clone point to clone the correct texture. The antennas also have been erased in the same manner. I also made the image higher by increasing the height in the Canvas Size. I didn't like how that hard edge of the sloping roof was taking you out of the picture, so I added some empty sky space above and drew the top of the roof with a brush in the Clone tool, cloning some of the roof texture to draw with. The sky was filled in the same manner. If I had just selected the empty sky shape and filled it with the Paintbrush tool, the color would not be the same as cloning it.

This painting was going to be done on a full sheet of watercolor paper, 21" x 29" or a proportion of width to length of 1.38. After determining the height I wanted of the sky shape, I cropped off some of the unexciting bottom of the road to retain those proportions in the computer file.

2. After removing the cars, I wanted to bring in some soft edges in front of the Tudor building, so I copied some of the flower shapes in Image B, pasted them in the main file, scaled them to be in proportion to the building (Scale command), and moved them into place. I had to adjust the scale several times to make them look in proportion. Another group of flowers was copied to indicate more texture to the left of the main doorway. (Image F)

The building on the left and the buildings down the street took you too far away from the scene, so I highlighted and copied those buildings, pasted them onto another layer, scaled them larger with the Scale tool, and moved them into place, covering up one of the buildings in the row. This brought the viewer closer to the scene. If you count the number of buildings to the left of the Tudor building, you will see that one is missing (compare Image E with Image F). This change also improved the sky shape, narrowing the width and making it more of an interesting shape.

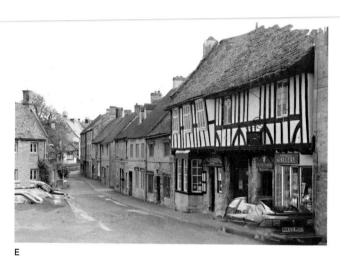

E

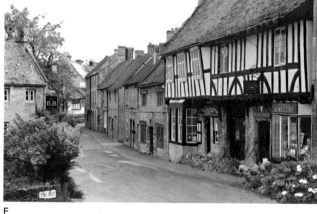

F

E *The cars from Image A are erased by cloning surrounding texture over them.*

F *The wall from Image D has been added to the lower left and the tree branches have been added behind the building on the left.*

G *Note how the cast shadow of the collection of buildings was used to tie the two sides of the street scene together.*

H *The added flowers and foliage in the painting have helped to soften the architectural elements.*

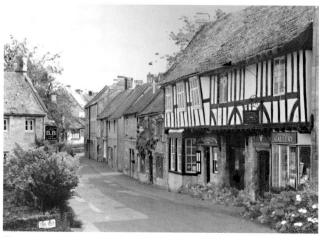

G

The lower left corner of Image E was also uninteresting because there was too much road, so I copied some of the stone wall and foliage in Image D, pasted it into the main file, scaled it, and moved it into its location. The unwanted sign in front of the wall was cloned over. I also cloned some of the tree branches from Image D behind the cottage on the far left to soften the sky shape and take the viewer into the scene. Other modifications I made were to copy the Bed and Breakfast sign in Image C and add it to the building on the left.

3. I added some tree branches with the Clone tool behind the Tudor building to soften that diagonal line (Image G). There were no branches this shape in any of my photos, so I selected a brush with the Clone tool and painted some cloned leaf texture in the shapes that I needed. If you look closely, you will see these branches aren't perfect, but doing it this way gave me more of a quick feeling of leaves than if I had just selected a flat green color and drawn them with the Paintbrush tool. The flat sky shape was highlighted with the Magic Wand tool, two colors of blue were selected in the Color Palette, and a Gradient was applied to the sky shape.

Today, these scenes have asphalt streets, but an artist does not have to paint them that way. The street was selected and the color balance was altered to warm it up considerably. The shapes of the shadows I had seen earlier that morning were drawn on the street with the Lasso tool, then made slightly darker and cooler to indicate the soft shadow of the buildings. These shadow shapes help to tie the composition together.

By the time I started painting this scene, I had worked out all of the problems and could concentrate on the application of colors and shapes (Image H). This is where your drawing skills and perspective knowledge come into play. Although the computer is doing a lot of instant work for you, you still must know how to tell the computer to make those modifications to have your image be believable. Rescaling architecture must be correct or your viewer will instantly notice that something is wrong. If you are creating a shadow from a building, you must make it look realistic.

H

Artists' Biographies

LEROY ALLEN

Leroy Allen was born in Kansas City, Missouri, and is a resident there. He graduated from the University of Kansas School of Fine Arts and went on to work for Hallmark Cards. Leroy's work is included in both private and corporate locations throughout the U.S. He was recently commissioned to paint the mayor of St. Louis, Missouri. Leroy has won many awards in juried exhibitions including those of the American Watercolor Society, California Watercolor Association, Watercolor USA, and Allied Artists of America. In addition, his work has been published on many occasions in magazines and television stations including CBS, NBC, and FOX.

PATRICIA ALLEN

Patricia Allen was born in Canada and now resides in Oakhurst, California. Patricia received a B.A. degree from St. Mary's College of California, Moraga. Patricia loves to work in watercolor and has exhibited in several one-person shows as well as group shows of the American Watercolor Society, California Watercolor Association, and Watercolor USA. She is a signature member of the Midwest Watercolor Society and Watercolor West and has won many awards in art competitions.

CATHERINE ANDERSON

Catherine Anderson was born in Chicago, Illinois, and attended the American Academy of Fine Art, University of Cincinnati, and Academy of Art College in San Francisco. She teaches numerous watermedia workshops at her studio in the Napa Valley vineyards and throughout the United States. Her paintings are found in several galleries and museums throughout the United States and China, and in corporate and private collections. She is a signature member of several watercolor societies, including the American Watercolor Society, National Watercolor Society, and Rocky Mountain National Watermedia Society and has won numerous major awards. Catherine's work has appeared in publications, such as *The Artist's Magazine* and *Southwest Art* magazine. She is also the author of the best-selling book, *Basic Watercolor Answer Book*. Her web site is: www.CatherineAnderson.net.

CHARLOTTE BRITTON

Watercolorist Charlotte Britton graduated from San Jose State University and has been a teacher of workshops in the U.S. and at the La Romita School of Art in Italy. Charlotte has taken painting groups to parts of the U.S. and Europe and is a founder of two art societies in California. Her work is represented in several galleries and she has been a selected juror for many exhibitions throughout the U.S. She has won over fifty awards in major exhibitions. Her signature memberships are American Watercolor Society, National Watercolor Society, and California Watercolor Association. Charlotte's work is published in *Mastering Color and Design* by Christopher Schink, *Splash 2,* and *Watercolor Magic,* Fall 1995 and Spring 1996.

GERALD BROMMER

Gerald Brommer studied at Concordia University, Nebraska; University of Nebraska, Lincoln (M.A.); Chouinard Art Institute; Otis Art Institute; UCLA; and USC, California. He taught high school art for over twenty-six years. Gerald teaches workshops all over the world in watercolor and related media and is associated with several artist workshop tour agencies. Gerald's work is in over 4300 private and corporate collections in forty states and nine countries. Gerald has won many major awards from the American Watercolor Society and the National Watercolor Society. His work has appeared in many books and other publications including *The Artist's Magazine, American Artist,* and *Southwest Art.* Gerald has written over twenty books for all levels of artists, such as *Collage Techniques, Art in Your Visual Environment,* and *Understanding Transparent Watercolor.*

JANE BURNHAM

Jane Burnham is basically a self-taught artist. She has been a successful teacher for over thirty years and has taught throughout the world. The last twenty have been at her National Paint Yosemite Workshop in Yosemite, California. This workshop has drawn people from all over the country. Jane is also called upon by colleges, and private organizations to jury shows, lecture, and demonstrate painting. She has received many awards and is a signature member of the American Watercolor Society and the National Watercolor Society.

DICK COLE

Dick Cole and his family live in Sonoma, California. He is a graduate of University of California, Los Angeles, and the Art Center College of Design. Dick has worked as a graphic designer, art director, and illustrator. His work is represented by galleries and in corporate and private collections such as Chevron, IBM, American Express, and Hewlett Packard. Dick has won a number of awards, such as the Gold Medal Award, California Association's National Exhibition 2000, and he was included in the National Watercolor Society's traveling show.

PAM DELLA

Pam Della was born and educated in South America and has resided in Contra Costa County in California for over forty-two years. She studied in a number of workshops, many of these with the late Jade Fon. Pam has taught pastel and oil classes for over twenty-five years and is represented in several galleries. She also enjoys organizing and taking groups abroad to paint in such places as Mexico, Costa Rica, Portugal, and Italy. She is the director of the prestigious Jade Fon Watercolor Workshop in Asilomar, California. Pam has won a number of top art awards and enjoys signature memberships in the Society of Western Artists and Pastel Society.

MARGARET EVANS

Margaret Evans graduated from the Glasgow School of Art; University of London, Graduate Institute of Education; and Teachers College. She tutors and gives workshops and demonstrations throughout the U.K., Italy, France, Spain, Norway, and the U.S. She likes to work in pastels, oils and watercolor. Margaret has authored a book called *Painting Figures and Animals with Confidence.* She has written a number of articles and has produced many teaching videos in watercolor, pastel, oil, and pen wash. In 1987, Margaret, along with her husband, Malcolm, established the Shinafoot Art Studios, located in Perthshire, Scotland.

MANETTE FAIRMONT

Manette Fairmont graduated with a B.A. from Principia College, Illinois. She further studied fine arts in England under the sponsorship of the same college. Her paintings are in museums, galleries, and private and corporate collections, such as the Springfield Art Museum in Springfield, Missouri; Universal Studios; and M.C.A. Home Box Office, Los Angeles, CA. Manette is a signature member of several art societies including the Springfield Art Museum, National Honorary Watercolor Society, National Watercolor Society, and the California Watercolor Association. She has won many major awards throughout the U.S and has been in a number of publications, such as *American Artist* magazine and *The Best of Watercolor.* The artist's web page is www.fairmontgallery.com or email: manetteart@aol.com.

ANNE FALLIN

Anne Fallin grew up in Warren, Pennsylvania. She started out as a nurse, and later studied art history at Boston University and the University of Rochester. Anne's artwork is in collections throughout the U.S. and Europe. Some of her work can be seen in the Wetter Gallery in Warren, Pennsylvania, and the Bitterroot National Forest Headquarters, Stevensville, Montana. Anne is a signature member of the American

Watercolor Society, National Watercolor Society, and California Watercolor Association. She has won many major awards, and has held many one-person shows and invitational group shows. She has been published in books and magazines, such as *Australian Artist, Allegheny* magazine, and *American Artist* magazine.

FRANK FEDERICO

Frank Federico attended Southwestern Louisiana Institute, Loyola University, New Orleans, and the John McCrady Art School, New Orleans. He teaches art at several locations including the West Hartford Art League in West Hartford, Connecticut, and the Rockport Art Association in Rockport, Massachusetts. He is represented by several galleries in the U.S. His paintings can be found in many private and corporate collections. Frank is a signature member of many organizations, such as the National Watercolor Society, International Association of Pastel Painters, Allied Artists of America, and more. He has won many major awards throughout his career and his work has appeared in a number of publications, as well as on television.

BOB GERBRACHT

Bob Gerbracht is a San Francisco portrait and figure painter and is a long-time, well-known art teacher. He works in pastels, oil, and watercolors. He is a winner of many major awards. His work has been published in books and magazines including *Who's Who in America, Who's Who in the West, Who's Who in American Art,* and *Who's Who in American Education.*

NORIKO HASEGAWA

Watercolorist Noriko Hasegawa was born in Japan and now resides in Sebastopol, California. She graduated with a Ph.D. in Pharmacy from Tokyo University, Japan. She is a master in Ikebana, Japanese flower arrangements, and other art-related areas. Her paintings can be found in museums and galleries in Japan and the U.S. She has exhibited at the Butler Institute of American Arts, National Academy of Design, and Tokyo Metropolitan Museum of Art to name a few. Noriko has won many major awards, such as the Springfield Art Museum Purchase Award, the Gold Medal of Honor and five awards from Audubon Artists, and the Gold Award for the California Watercolor Association National Exhibition. Her work has been published in several magazines and newspapers, including *Best of Watercolor, One, Two,* and *Three.*

JANE HOFSTETTER

Jane Hofstetter attended the University of California in Berkeley and the Chouinard Art Institute in Los Angeles. She has been teaching for over twenty years throughout the world and works in several mediums. Her work is in private and corporate collections and is represented in several galleries. She is a signature member of several art organizations, such as the National Watercolor Society, Watercolor West, Midwest Watercolor Society, and California Watercolor Association. Jane's work has appeared in many national and international magazines, books, and catalogs. Jane is presently writing an art book on her theories of color and design.

GERI KEARY

Geri Keary was born in Salt Lake City, Utah. She developed her art by attending classes and various workshops. Later, she taught art classes at the Martinez Unified School District in California. She is represented by California galleries. She likes to paint in acrylics, oil, and watercolor and her works are in many private and corporate collections. Geri is a signature member of several societies, including the National Watercolor Society, American Watercolor Society, and California Watercolor Association, and she has won many major awards. Geri has appeared in several publications, including an article she wrote for *Acrylic Techniques* magazine.

MELANIE LACKI

Melanie Lacki lives in Pleasanton, California. After finishing college, she pursued a career in the advertising business, as a graphic illustrator and art director for two newspapers. Melanie teaches watercolor workshops and gives lectures and demonstrations. Private and corporate collectors throughout the world have added her work to their collections. She is a signature member of several watercolor organizations, such as the National Watercolor Society, Rocky Mountain National Watercolor Society, California Watercolor Society, and Watercolor West. Melanie has won many major awards and has also appeared in several publications including *Creative Watercolor, Best of Flower Painting,* and *Painting Great Pictures from Photographs.*

DALE LAITENEN

Dale Laitenen lives and works in the mountains of California. He is a graduate of San Jose State University. Dale teaches workshops across the U.S. and conducts his own annual Dale Laitenen High Sierra workshop. He is represented in eight galleries in the California area. Dale exhibits his work across the U.S., and has held several solo and group shows. He is a signature member of the National Watercolor Society and Watercolor West, and has won many major awards. His articles and paintings have been published in *The Artist's Magazine, Watercolor Magic,* the *Splash* series, and several other books.

JULIE LIMBERG

Julie Limberg is a native of Chicago, Illinois, and a graduate of Bradley University. She has studied at the Art Institute of Chicago, University of Colorado, and the Instituto de Allende, Mexico. Julie has been a professional artist for over twenty-five years and works almost exclusively in watercolor. She is currently an instructor for the Yosemite Association at Yosemite National Park, California. Julie has won many awards and her work is in art collections around the world. She is represented in the following California galleries: Valley Art Gallery, Walnut Creek; CWA Gallery, Concord; CWA Blackhawk Gallery, Danville; and by Lisa Lodeski Fine Arts Gallery, Aliso Viego.

JERRY JAMES LITTLE

Jerry James Little is a native of California and received a degree from Delta College in California. He continued his studies at the University of Oregon. Jerry gives lectures and demonstrations on the experimental approach to art and works in all mediums. Jerry has gallery representation and his work is in collections in the United States, Europe, and Japan. He is the past president of the California Watercolor Association. He is a signature member of the National Watercolor Society and California Watercolor Association and has won many awards. His work has been in several books and magazines including *International Artist* and *The Artist's Magazine,* in which he authored an article demonstrating his techniques. The artist's web site is www.californiawatercolor.org/gallery/littlej.htm.

RICHARD MCDANIEL

Richard McDaniel studied painting at the Art Students League in New York, sculpture at San Diego State University, and earned an M.F.A. degree from the University of Notre Dame. Richard taught drawing and painting at the Woodstock School of Art for over twenty years. Richard has returned to California and is now teaching at the Pacific Academy of Fine Arts and continues to conduct workshops throughout the U.S. and overseas. Richard's drawings, pastels, and other mediums are represented by galleries in California, Oregon, and New York and his artwork is in collections nationwide. He is a signature member of several art organizations including the Oil Painters of America and Pastel Society of America. Richard has appeared in several publications, such as *International Artist* and *American Artist.* He also is the author of four books featuring his art and teaching. The artist may be contacted at his web site: www.richardmcdaniel.com.

DONNA MCGINNIS

Donna McGinnis was born in Spokane, Washington, and received her B.A. in Fine Arts from Washington State University, Pullman. Her art training allows her to use most mediums. Donna has lectured at colleges and museums, and her paintings are in many private and corporate collections throughout the world. Donna has had over thirty solo exhibitions, seventy group exhibitions, and won numerous awards. She has been published in a number of newspapers and magazines including *Who's Who in American Women, American Artist,* and *Designers West.*

STEVE MEMERING

Steve Memering received a B.A. degree from the University of California, Berkeley, and an M.F.A. and teaching credential from California State University of Sacramento. Steve teaches full time at W.E. Mitchell Middle School in Sacramento. Steve works in all pigments and is often commissioned to do commercial art projects for the drama department at California State University of Sacramento and a theater in that area. Five galleries currently represent his work.

JUDY MORRIS

Judy Morris earned B.S. and M.S. degrees in art education from Southern Oregon University. She taught at South Medford High School in Oregon for thirty years until 1996 when she became a full-time professional watercolorist. Judy has been a popular juror and workshop instructor, teaching in many areas around the world. Her artwork can be seen in public and private collections around the world and in several galleries. She is a signature member of the American Watercolor Society, National Watercolor Society, Midwest Watercolor Society, Northwest Watercolor Society, and has won numerous awards. Judy's work has been published in more than a dozen books and publications, including *Splash 4*, and *Splash 5*, and she is the author of *Watercolor Basics: Light*. The artist's web site is www.judymorris-art.com.

JANN LAWRENCE POLLARD

Jann's love of art and travel combined with a study of old world architecture and interior design developed her style of painting. With a B.F.A. degree in Interior Design from the University of Colorado, Boulder, she continued her art studies with several well-known instructors, as well as at the College of San Mateo, California. Jann is a signature member of the National Watercolor Society, California Watercolor Society, and the Society of Western Artists, and she has become a popular teacher of workshops, both nationally and internationally. Her work was been featured in an article in *International Artist* magazine, and she is the co-author of this book. She has several fine art prints and posters and is the cover artist for the lauded Karen Brown travel books series. Jann's paintings are represented through California galleries in Carmel, Napa Valley, and Burlingame. Her works are in collections internationally. The artist's web site is www.jannpollard.com.

RON RANSON

Ron Ranson grew up in England. He was an English engineer and started his painting career later in life. He travels the world teaching watercolor workshops in Greece, Italy, Norway, Africa, New Zealand, the U.S., and Australia. Ron has written twenty-seven books and has many videos to his credit. He helped found *International Artist* magazine, and until recently, was its European Editor-at-Large. The artist's web site is: www.ronranson.com.

RANDALL SEXTON

Randall Sexton is a native of East Hampton, Connecticut. He attended the Academy of Art in San Francisco and has further studied with several prominent artists. Randall's education and natural-born talent enabled him to teach at several locations in California, including the Academy of Art College in San Francisco, Tippett Studios in Berkeley, and private landscape workshops. He works in oil and pastel. Randall has held a number of one-man exhibitions at the John Pence Gallery in San Francisco, as well as many group shows in the general area. His work may be currently seen at the John Pence Gallery in San Francisco. He has been published in several magazines including *American Artist*, *Nob Hill Gazette* (cover), and as a featured artist in *Plein Air Scene*.

PENNY SOTO

Penny Soto lives in San Ramon, California. She attended Chabot College in Hayward and the Academy of Art College in San Francisco, where she had a $10,000 scholarship to pursue a degree in illustration. Her paintings can be seen in many galleries and museums and in private and corporate collections, such as Nordstrom's Stores throughout the U.S., Kaiser Foundation, Pepsi Corporation, and Ralston Purina Corporation. She has signature memberships in the California Watercolor Association and the Society of Western Artists. Penny has been published in many publications such as *The Artist's Magazine, Artists of Central and Northern California,* and *Best of Florals 2.* The artist's web site is www.sotofineart.com.

CLAIRE SCHROEVEN VERBIEST

Claire Shroeven Verbiest is a native of Belgium and now resides in San Jose, California. She teaches classes and conducts workshops, while working in pastels and watercolor. Her work is represented in numerous collections. Claire is a signature member of several watercolor organizations including the California Watercolor Association and has won many prestigious awards. In 1999, she won the High Winds Award in the American Watercolor Society's Show and a recent Gold Medal Award from the California Watercolor National Show. Claire has appeared in numerous publications such as *Splash 4* (cover artist), *Floral Inspirations, The Best of Portrait Painting, The Best of Pastel,* and *International Artist.*

JEAN WARREN

Jean Warren attended the University of California, Berkeley, and California College of Arts and Crafts, and received a B.A. in Art Education from Glassboro-Rowan University, New Jersey. She coordinated and taught elementary art education in New Jersey and California. Jean's paintings are in several galleries and in collections in the U.S., Europe, and Asia. Watercolor is her passion. She is a member of several art organizations and has signature memberships in the National Watercolor Society and the California Watercolor Association and is the past president of that association. Jean's work has appeared in many publications, such as *Best of Watercolor, Motorland AAA Magazine,* and the cover of *Places in Watercolor.*

GERRY WILLGING

Gerry Willging lives with her family in Rancho Palos Verdes, California, and also spends time in her studio in Newberryport, Massachusetts. She has studied with a number of master artists and now teaches popular workshops. Gerry paints in most mediums to establish her experimental techniques. Her work has been exhibited in museums in England and the U.S. Gerry is a signature member of the Taos Society of Watercolorists, California Watercolor Association, and NAPA. Gerry's work has been featured in several publications including *Artistic Touch, International Artist,* and *Watercolor* magazines.

EDWIN WORDELL

Edwin Wordell attended several California schools, including the San Diego School of Arts and Crafts, La Jolla, and Coronado School of Arts, and he earned a B.S. degree from San Diego State College. Edwin has been a selected juror for many shows including those of the National Watercolor Society. He has taught workshops all over the world that feature all ranges of mediums and his paintings are in collections throughout the world. He also has many signature memberships such as the National Watercolor Society, Watercolor West, Rocky Mountain Watercolor Society, Society of Experimental Artists, and National Society of Painters in Casein and Acrylic. Edwin has won many major awards, and his work has appeared in many publications including *Who's Who in American Art, American Artist, The Artist's Magazine,* and *Creative Collage* by Nita Leland and Virginia Lee Williams.

Index